BERKS &
HANTS LINE
THROUGH TIME
Stanley C. Jenkins
& Martin Loader

AMBERLEY PUBLISHING

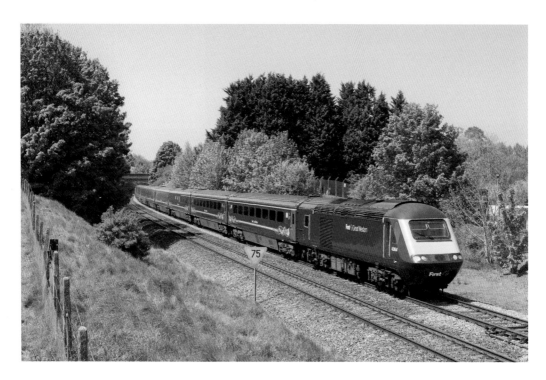

A Present-Day Train Near Hungerford

A Penzance to Paddington express headed by HST power car No. 43164 on the Berks & Hants route at Hungerford common on 22 May 2012.

First published 2013

Amberley Publishing
The Hill, Stroud, Gloucestershire, GL5 4EP
www.amberley-books.com

Copyright © Stanley C. Jenkins & Martin Loader, 2013

The right of Stanley C. Jenkins & Martin Loader to be
identified as the Author of this work has been asserted in
accordance with the Copyrights, Designs and Patents Act
1988.

ISBN 978 1 4456 2312 2 (print)
ISBN 978 1 4456 2317 7 (ebook)

British Library Cataloguing in Publication Data.
A catalogue record for this book is available from the
British Library.

Typesetting by Amberley Publishing.
Printed in Great Britain.

Introduction

The Great Western Railway Company was incorporated by Act of Parliament on 31 August 1835, with powers for the construction of a railway between Bristol and London. The authorised capital was £2,500,000 in shares, together with a further £833,333 by loans. As originally proposed, the Great Western would have been a standard gauge line, but Isambard Kingdom Brunel (1801–59), the Great Western engineer, recommended that the line should be built to a broad gauge of 7 feet, and this suggestion was accepted by the GWR directors.

The first section of the Great Western main line was opened on 31 May 1838 from London to Maidenhead, when a special train conveyed the directors and their invited guests over the new railway. The line was extended westwards from Maidenhead to Twyford on 1 July 1839, and to Reading on Monday 30 March 1840. Further sections of line were brought into use at intervals, and the GWR route was completed throughout, from Paddington to Bristol Temple Meads, on 30 June 1841.

Reading was, from the very start, an important traffic centre on the GWR main line, and its importance was enhanced when further lines were opened to Basingstoke and Hungerford. A scheme for the construction of broad gauge lines from Reading to Basingstoke and Newbury was proposed during the 'Railway Mania' years of the 1840s, but the bill was opposed by the London & South Western Railway (L&SWR), which hoped to build a rival standard gauge line. In the event, Parliament preferred the GWR-backed scheme, and 'The Berks & Hants Railway' bill received the Royal Assent on 30 June 1845.

The resulting Act of Parliament authorised the construction of two new lines, one of which would run westwards from Reading to Hungerford, while the other would extend southwards from Reading to Basingtoke. The western arm was opened between Reading and Hungerford on 21 December 1847, and the Basingstoke branch was completed between Southcote Junction and Basingstoke on 1 November 1848. Powers for a further extension from Hungerford to Westbury were obtained in that same year, but the Berks & Hants Extension scheme foundered as a result of the economic crisis that followed the Railway Mania.

The Berks & Hants Extension Railway was resurrected, in modified form, at the end of the 1850s, the necessary Act of Parliament being obtained on 13 August 1859. As in 1848, the proposed line would form a continuation of the Hungerford route, although Devizes would replace Westbury as the western 'terminus' of the proposed extension. Here, connection would be made with the existing Devizes branch – which would then become part of a circuitous broad gauge route between Reading, Hungerford, Devizes, Trowbridge and Westbury. Construction was soon in progress, and the Berks & Hants Extension was opened from Hungerford to Devizes on 11 November 1862.

In the meantime, the broad gauge system had continued to expand, the Bristol & Exeter Railway being opened in 1844, while the South Wales line was completed throughout to Milford Haven in 1856. Meanwhile, the West of England main line was being pushed westwards in stages, the final links being provided by the West Cornwall Railway and the Cornwall Railway, which were completed in 1852 and 1859 respectively – thereby establishing a continuous line between Paddington and Penzance (albeit with a break-of-gauge at Truro).

The 7-foot gauge was abandoned at the end of the nineteenth century and, at about the same time, the GWR decided to shorten its main line routes between London, Wales, the Midlands

and the West of England by creating a series of 'cut-off' lines. As far as the Berks & Hants route was concerned, it was envisaged that two such 'cut-offs' would be built. One of these would run from Patney and Chirton to Westbury, and the other would extend westwards from Castle Cary to Curry Rivel Junction near Langport, where the 'cut-off' would converge with an earlier Bristol & Exeter line from Durston to Yeovil, which would be followed for 4 miles as far as Athelney. From Athelney, a new section of line would run south-westwards to join the Bristol & Exeter main line at Cogload Junction.

The West of England improvement scheme was completed on 9 June 1906, giving the GWR a shortened route to the west – the distance from Paddington to Penzance being reduced to 305½ miles, as opposed to 325½ miles via Bristol. The Berks & Hants route thereby became an integral part of the West of England main line between Paddington and Penzance.

Acknowledgements

Thanks are due to Dr Peter Fidczuk for the supply of photographs used in this book (p. 12). Other images were obtained from the Lens of Sutton Collection, and from the authors' own collections.

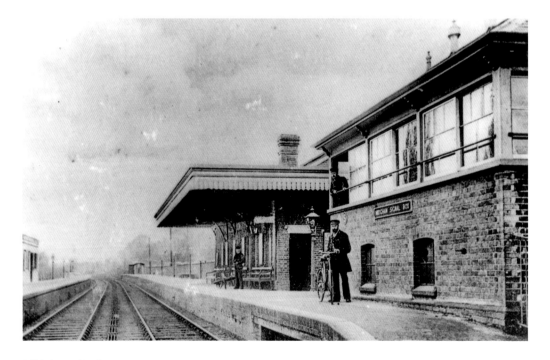

Midgham Station
This Edwardian postcard shows Midgham station during the early years of the twentieth century. This station is situated on the original section of the Berks & Hants route between Reading and Hungerford.

Unemployment Relief Schemes

The improved West of England main line had been obtained by the piecemeal construction of a series of different lines, and the resulting route was by no means ideal – sharp curvature at Westbury and Frome stations being a particular problem. It was therefore decided that further bypass lines would be built to the south of both stations – the Frome 'cut-off' being 2½ miles in length, while the Westbury 'cut-off' would be slightly shorter. The Westbury and Frome 'cut-offs' were built with the aid of financial assistance from the government – cheap loans having been offered to the railways for a variety of major civil engineering schemes, which would alleviate the effects of mass unemployment during the Great Depression. The contract for work on the Frome and Westbury 'cut-off' lines was placed with Messrs Logan & Hemingway of Doncaster in 1930, and the new lines were brought into use for goods traffic on 1 January 1933.

Another development initiated during the early 1930s under the government-funded job creation scheme concerned the remodelling of Cogload Junction and the main line through Taunton. It was agreed that the existing 'flat' junction would be replaced by a flying junction, the down line from Bristol being carried over the up and down Paddington lines on a massive skew girder bridge. From Cogload, quadruple trackwork would be continued westwards through Taunton to Norton Fitzwarren, a distance of 8 miles, while Taunton station would be completely remodelled with four main through platforms. This ambitious remodelling scheme was undertaken by Messrs Scott & Middleton at a cost of around £360,000, and when completed in 1932, it resulted in a spacious and much improved station layout at Taunton, and a high-speed junction for main line trains travelling between Paddington and the West of England.

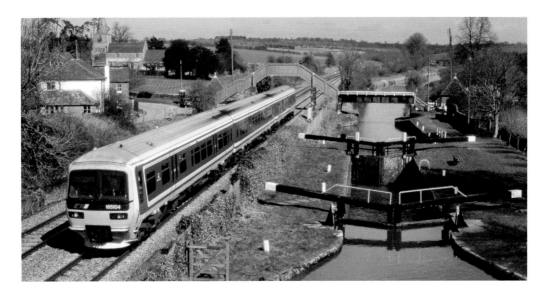

Beside the Kennett & Avon Canal
The Kennet & Avon Canal was completed in 1810 and taken over by the GWR on 1 July 1851. This picturesque waterway runs parallel to the Berks & Hants route for many miles, as shown in this 1999 view, which depicts class '165' unit No. 165104 beside the locks at Little Bedwyn.

TABLE I: The Berks & Hants Route: Summary of Opening Dates

Section of Line	Built by	Opened
Reading Station	GWR	30 March 1840
Reading East Junction to Hungerford	Berks & Hants Rly	21 December 1847
Hungerford to Patney & Chirton	Berks & Hants Extension Rly	11 November 1862
Patney & Chirton to Westbury	GWR	1 October 1900
The Westbury Station 'cut-off'	GWR	1 January 1933
Westbury to Castle Cary	Wilts, Somerset & Weymouth Rly	7 October 1850
The Frome Station 'cut-off'	GWR	1 January 1933
Castle Cary to Charlton Mackrell	GWR	1 July 1905
Charlton Mackrell to Curry Rivel Junction	GWR	1 July 1906
Curry Rivel Junction to Athelney Junction	Bristol & Exeter Rly	1 October 1853
Athelney Junction to Cogload Junction	GWR	1 July 1906
Cogload Junction to Taunton	Bristol & Exeter Rly	1 July 1842

TABLE II: Opening Dates of Individual Stations

Station	Distance From	Opened	Status
Reading	35 miles 78 chains	30 March 1840	Open
Reading West	36 miles 72 chains	1 July 1906	Open
Theale	41 miles 23 chains	21 December 1847	Open
Aldermaston	44 miles 63 chains	21 December 1847	Open
Midgham	46 miles 59 chains	21 December 1847	Open
Thatcham	49 miles 45 chains	21 December 1847	Open
Newbury Racecourse	52 miles 31 chains	26 September 1905	Open
Newbury	53 miles 07 chains	21 December 1847	Open
Kintbury	58 miles 38 chains	21 December 1847	Open
Hungerford	61 miles 43 chains	21 December 1847	Open
Bedwyn	66 miles 33 chains	11 November 1862	Open
Savernake Low Level	70 miles 08 chains	11 November 1862	Closed 16 April 1966
Wootton Rivers Halt	72 miles 43 chains	24 September 1928	Closed 16 April 1966
Pewsey	75 miles 26 chains	11 November 1862	Open
Manningford Halt	76 miles 62 chains	20 June 1932	Closed 16 April 1966
Woodborough	78 miles 69 chains	11 November 1862	Closed 16 April 1966
Patney & Chirton	81 miles 07 chains	1 October 1900	Closed 16 April 1966
Lavington	86 miles 72 chains	1 October 1900	Closed 16 April 1966
Edington & Bratton	91 miles 32 chains	1 October 1900	Closed November 1952
Westbury	95 miles 46 chains	1 September 1848	Open
Frome	101 miles 27 chains	7 October 1850	Open
Witham	106 miles 60 chains	1 September 1856	Closed 3 October 1966
Strap Lane Halt	108 miles 36 chains	18 July 1932	Closed June 1950
Bruton	111 miles 71 chains	1 September 1856	Open
Castle Cary	115 miles 29 chains	1 September 1856	Open
Alford Halt	117 miles 35 chains	1 July 1905	Closed 8 September 1962
Keinton Mandeville	120 miles 17 chains	1 July 1905	Closed 8 September 1962
Charlton Mackrell	122 miles 30 chains	1 July 1905	Closed 8 September 1962
Somerton	125 miles 56 chains	2 July 1906	Closed 8 September 1962
Long Sutton & Pitney	127 miles 70 chains	1 October 1907	Closed 8 September 1962
Langport East	129 miles 73 chains	2 July 1906	Closed 8 September 1962
Athelney	134 miles 74 chains	1 October 1853	Closed 13 June 1964
Lyng Halt	135 miles 59 chains	24 September 1928	Closed 13 June 1964
Creech St Michael	140 miles 02 chains	13 August 1928	Closed October 1964
Taunton	142 miles 72 chains	1 July 1842	Open

NB: Closure dates refer to the last day of operation

Recent Developments

The nationalisation of Britain's railways on 1 January 1948 made little appreciable difference to the Berks & Hants route, which continued to operate as an integral part of the West of England main line between Paddington and Penzance. However, in the longer term, the British Railways era was a period of relative decline – the rapid development of road transport having resulted in an inexorable loss of traffic, particularly in rural areas. The first closures on the Reading to Taunton route were implemented during the 1950s – the victims being the little-used stopping places at Strap Lane and Edington, which were deleted from the railway system in June 1950 and November 1962 respectively.

The pace of closure and retraction sped up after 1958, when Ernest Marples (1907–78) was appointed Minister of Transport by Conservative Prime Minister Harold Macmillan. Marples, the founder of a major civil engineering firm, was known to be in favour of grandiose motorway construction schemes, and in the next few years the ruling political party adopted an increasingly hostile attitude towards the nationalised railways, which culminated in 1963 with the publication of the Beeching Plan for the 'reshaping' of British Railways.

Meanwhile, in 1962, it had been announced that passenger services would be withdrawn from several stations at the western end of the line. The stations concerned were Alford, Keinton Mandeville, Charlton Mackrell, Somerton, Long Sutton & Pitney and Langport East, all of which were closed with effect from Monday 10 September, the last trains running on Saturday 8 September 1962. Athelney was closed on Saturday 13 June 1964, together with the Taunton to Yeovil branch, while further closures took place on Saturday 16 April 1966, when passenger services were withdrawn from a further nineteen stations in Wiltshire, including Savernake Low Level, Wootton Rivers Halt, Manningford Halt, Woodborough, Patney & Chirton and Lavington. Witham survived until 13 June 1964 when it too was eliminated, in conjunction with the branch to Cheddar and Yatton.

These deletions meant that, by the end of the 1960s, the Berks & Hants route had reached its present-day form as a main line link between Reading, Newbury, Westbury and Taunton, and a commuter route between Reading, Newbury and Pewsey. The line also carries large amounts of stone traffic from the rail-linked quarries at Merehead and Whatley, this important source of bulk freight traffic being centred on Westbury.

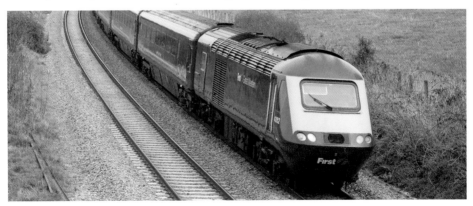

Wootton Rivers
A Penzance to Paddington express headed by HST power car No. 43512 speeds eastwards on the Berks & Hants route near Hungerford, on 22 May 2012. HST sets have worked long-distance services on the West of England main line since the 1980s.

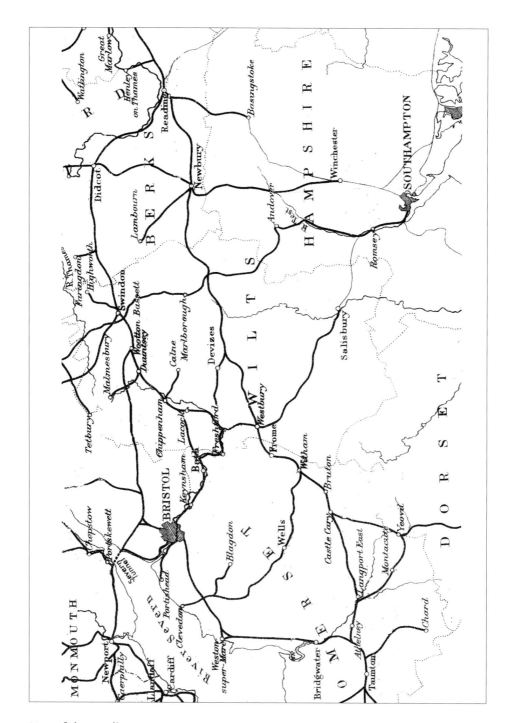

Map of the Reading to Taunton Route
A map of the Great Western system in Wessex, showing the direct Berks & Hants route from Reading to Taunton via Newbury, Westbury and Castle Cary, and the old main line via Didcot, Swindon and Bristol. It will be noted that, notwithstanding its name, the Berks & Hants route runs through Berkshire, Wiltshire and Somerset – the Basingstoke branch being the only link with Hampshire!

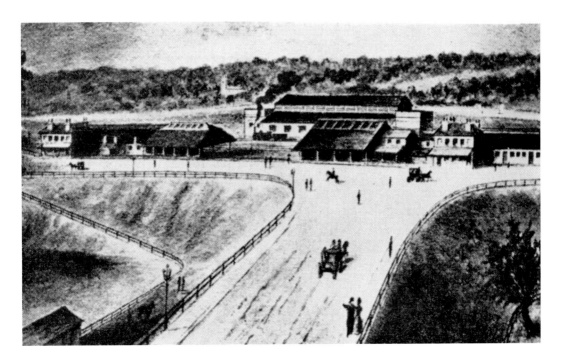

Reading: The Original Station

When first opened in 1840, Reading featured one of the Great Western's 'single-sided' station layouts, with separate platforms for up and down traffic on the down side of the line. There were two cavernous wooden train sheds, together with separate station buildings for up and down traffic, both of these being two-storey hip-roofed structures, as depicted in this contemporary print. A much-improved station building was subsequently built, although, as shown in the lower view, the single-sided track layout was retained for many years.

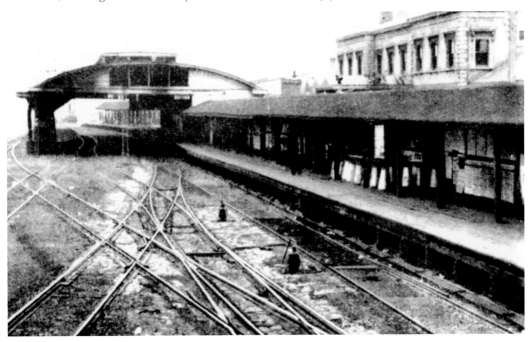

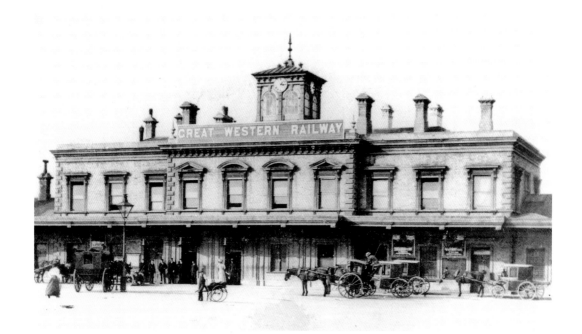

Reading: The Main Station Building

Above: This Edwardian postcard provides a detailed view of the main station building, which was a two-storey, Italianate structure with a low-pitched, hipped roof, surmounted by a raised lantern or belvedere. The building was constructed of yellowish-grey brickwork with stone dressings, while further visual interest was provided by a profusion of ornate chimney stacks and decorative window heads. This distinctive building is now a popular pub known as The Three Guineas. *Below*: A platform view, looking east towards Paddington during the BR period on 3 July 1952.

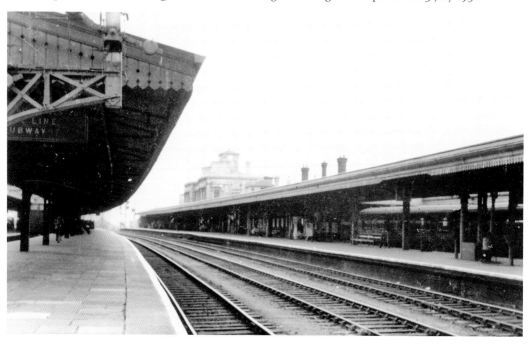

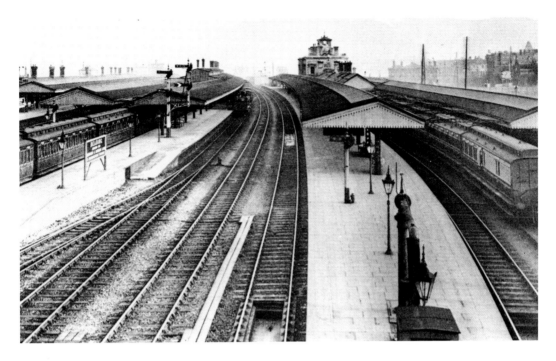

Reading: Platform Scenes

Reading Station underwent several changes during the Victorian period, and by the end of the nineteenth century it had been rebuilt, with four lengthy through platforms and a number of terminal bays, which, in recent years, have been numbered in logical sequence from one to ten. The platforms were covered by extensive canopies with characteristic GWR 'V-and-hole' valancing, as shown in the upper picture, which dates from around 1912. The lower picture shows Platform 3 during the British Railways period around 1962.

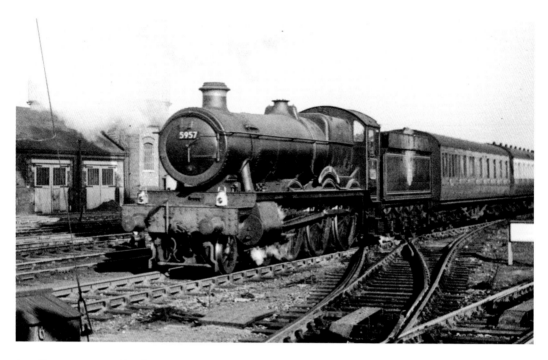

Reading: Steam & Diesel Power at Reading

Above: 'Hall' class 4-6-0 No. 5957 *Hutton Hall* at Reading in 1952. *Below*: Class '117' unit No. L418 at Reading in 1986. The station is one of the busiest on the Great Western system. In 1937, it issued 606,165 ordinary tickets and 12,454 seasons, while by the mid-1980s Reading was generating around 10,800,000 passenger journeys per annum, rising to 15¼ million by 2012. At the time of writing, the station is being extensively rebuilt, with four new platforms on the north side.

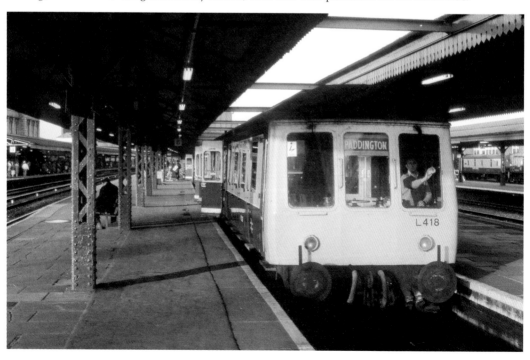

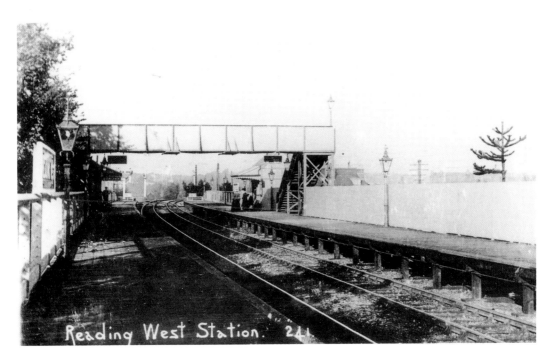

Reading West Station. 24

Reading West

The Berks & Hants route begins at Reading East Junction and on leaving Reading, trains climb at 1 in 307 towards the first intermediate station at Reading West (36 miles 72 chains). Opened on 1 July 1906, this has always been a passenger-only stopping place, although Southcote Junction, at the south end of the platforms, formerly gave access to the Reading Central goods branch; Southcote Junction is also the starting point for the Basingstoke line. The accompanying photographs date from *c*. 1912 and around 1962.

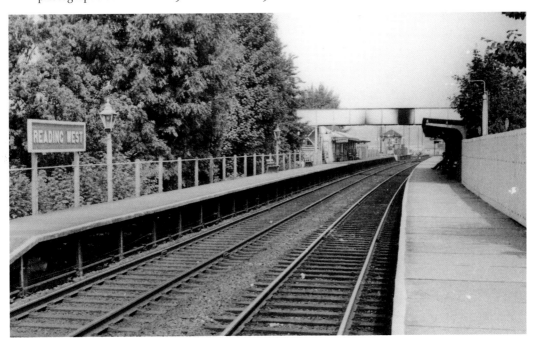

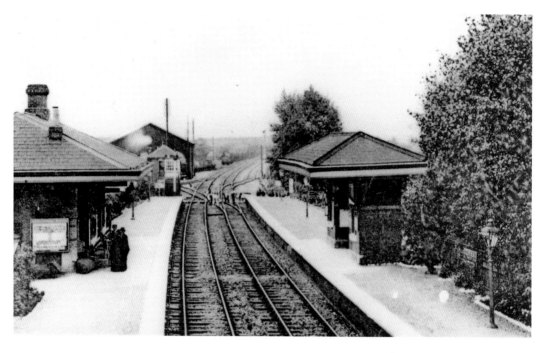

Theale: Brunelian Architecture

Parting company with the Basingstoke line, the Berks & Hants route heads west-south-westwards along the Kennet Valley, with the railway-owned Kennet & Avon Canal running parallel to the left. Theale, 41 miles 23 chains from Paddington, was one of the original Berks & Hants stations, having been opened on 21 December 1847. Prior to rationalisation, it had boasted a typical Brunel-designed chalet building, as shown in these two photographs, both of which date from the early years of the twentieth century.

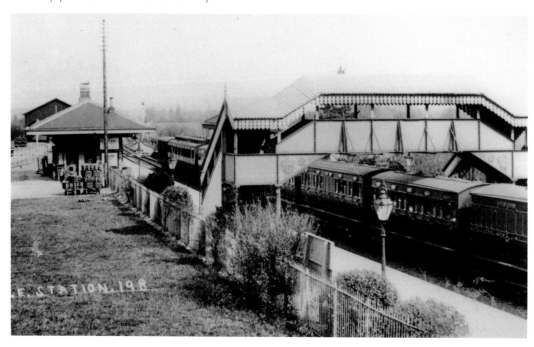

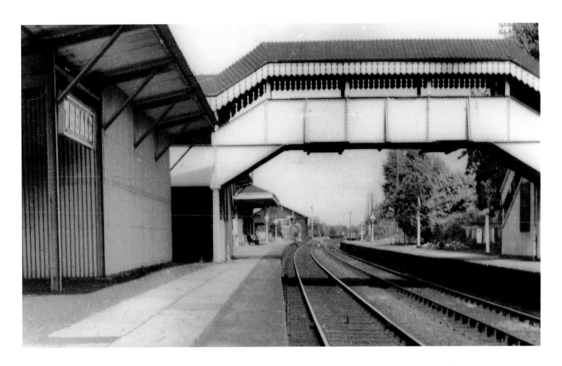

Theale

The infrastructure at Theale has been simplified and the goods yard was closed in 1970, although a Foster Yeoman stone plant remains in operation. The upper view shows the station during the 1960s, before demolition of the station buildings, while the colour photograph shows an HST set led by power car No. 43019 at Ufton Nervet, between Theale and Aldermaston, on 30 March 1990. In a terrible coincidence, No. 43019 was written off in an accident that occurred at Ufton Nervet on 6 November 2004, when a suicidal motorist parked his vehicle on the level crossing.

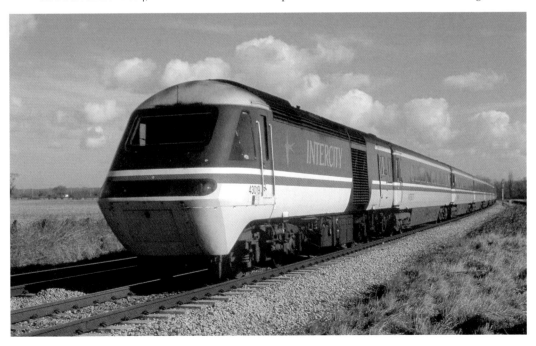

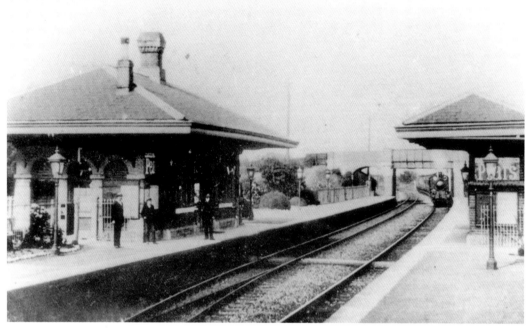

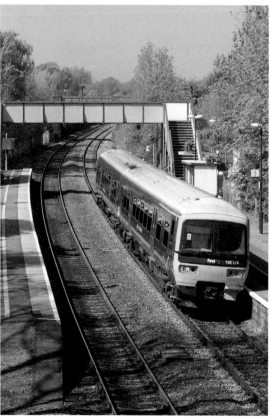

Aldermaston: The Brunelian Station Buildings

Aldermaston, the next station (44 miles 63 chains), is very similar to Theale. It was opened in 1847 and featured Brunelian chalet-style buildings; these distinctive Italianate structures were of red-brick construction, although, sadly, they have now been demolished. The sepia postcard is looking east towards Paddington around 1912, while the colour photograph is looking westwards on 8 May 2008. It shows First Great Western class '165' unit No. 165124 standing alongside the up platform with the 10.13 a.m. Newbury to Reading local service.

Aldermaston, Theale, Midgham and Thatcham survived the Beeching closures, and these suburban stations are now served by a frequent service of local trains operating as far west as Newbury. These all-stations workings generally run at hourly intervals, with another hourly train to Bedwyn slotted in. In addition, longer-distance services run to and from Bedwyn, but these normally call only at Theale and Thatcham.

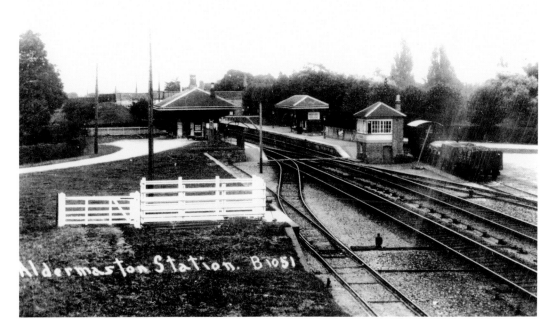

Aldermaston: Then & Now

Above: A general view of Aldermaston station around 1910, with the cattle loading pens in the foreground and the Brunelian station buildings visible in the distance. *Below*: Class '165' unit No. 165137 pulls away from Aldermaston while working the 9.12 a.m. Reading to Newbury First Great Western service on 1 August 2009. This part of the line was converted from broad gauge to standard gauge in June 1874, the wider-than-usual spacing between the up and down lines being a legacy of the original 7-foot gauge.

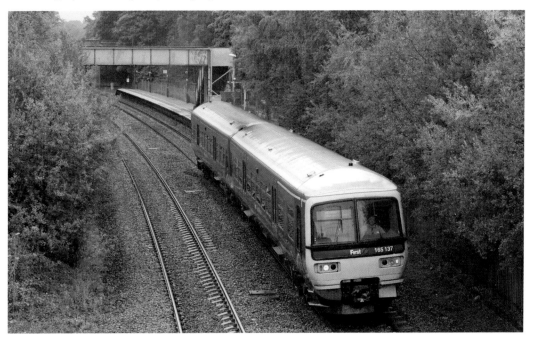

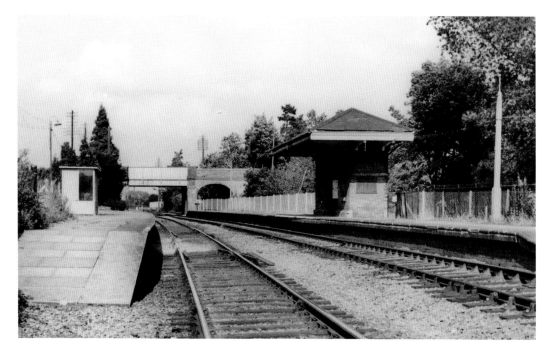

Aldermaston: The Present-Day Station

Aldermaston became an unstaffed halt in the 1960s, and its facilities were progressively rationalised. The upper photograph shows the station around 1970, after removal of the main station building. Aldermaston has, nevertheless, remained relatively busy, and in recent years it has generated around 60,000 passenger journeys per annum. The colour view shows class '165' unit No. 165111 speeding eastwards through the station on 8 May 2008 with the 10.37 a.m. First Great Western semi-fast service from Bedwyn to Paddington.

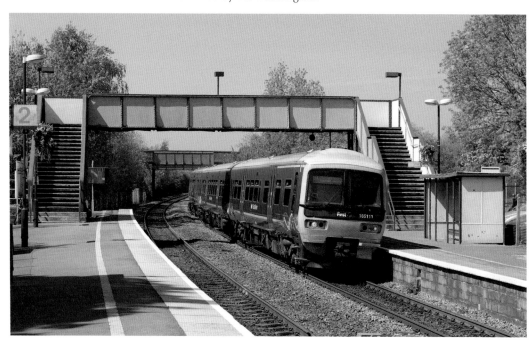

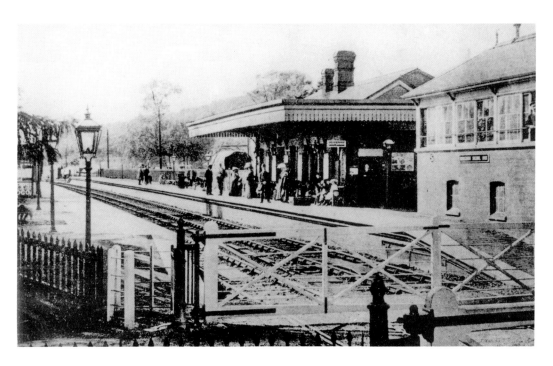

Midgham: Before Rationalisation

Continuing westwards along the Kennet Valley, down trains soon reach Midgham (46 miles 59 chains), which was known as Woolhampton until 1873, when the present name was adopted. The upper view provides a glimpse of this Berkshire station around 1912, while the lower view, dating from the 1960s, is looking eastwards along the up platform towards Paddington. The buildings that can be seen in these photographs have been demolished, and the level crossing is now equipped with lifting barriers.

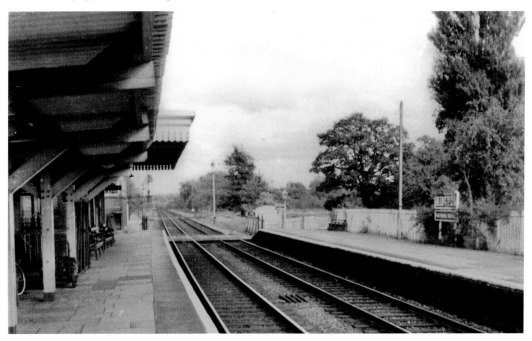

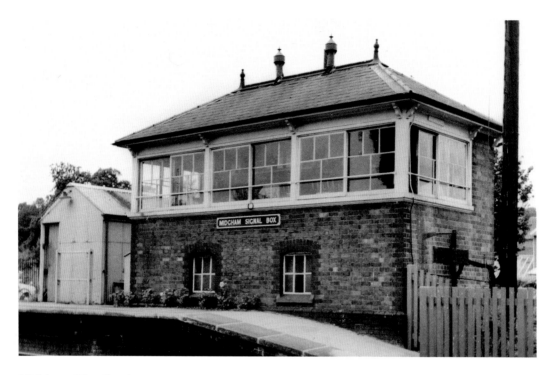

Midgham: The Signal Box

Above: A detailed view of Midgham signal box, which was of standard Great Western design, with a hipped roof and distinctive five-pane 'high visibility' windows that were supposed to give signalmen an unimpeded view. Buildings of this same general type were erected all over the GWR system from around 1896. *Below*: Collett '14XX' class 0-4-2T No. 1444 stands alongside the up platform at Midgham, with a single-coach push-pull working, around 1958.

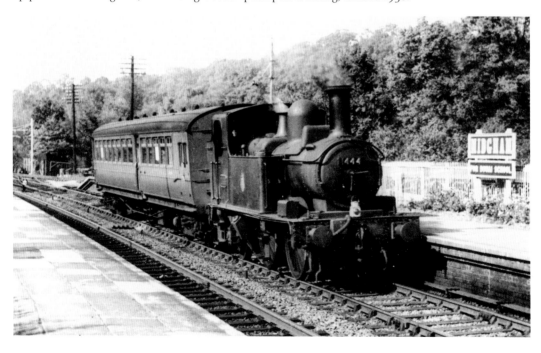

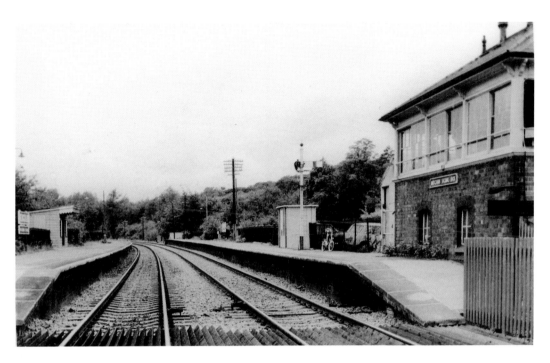

Midgham

Above: A general view of the station, looking west towards Penzance during the 1970s. The main station building has been replaced by a simple waiting shelter, but the signal box and gated level crossing were, at that time, still in situ. *Below*: First Great Western class '180' unit No. 180107 passes Brimpton (between Midgham and Colthrop) with the 12.18 p.m. Paddington to Exeter St Davids service on 23 November 2007.

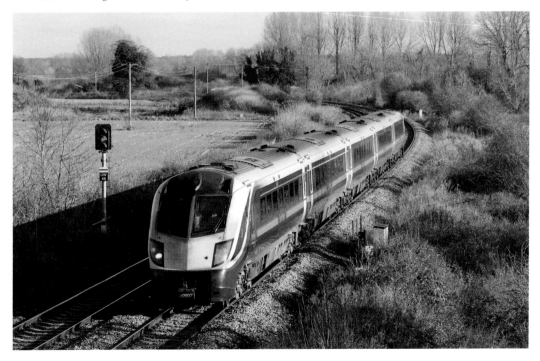

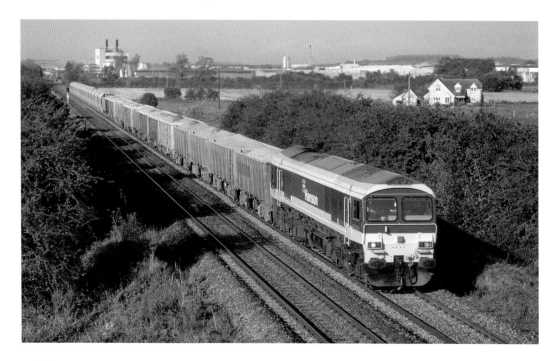

Midgham: Stone Trains Near Midgham

The upper view shows class '59' locomotive No. 59104 *Village of Great Elm* passing Brimpton with the 7.05 a.m. Merehead to Acton 'jumbo' Mendip Rail stone train on 19 October 2000. The lower photograph shows the sister locomotive No. 59103 *Village of Mells* with the late-running 9.45 a.m. Theale to Merehead stone empties on 23 November 2007. These heavy stone trains have, in recent years, become familiar sights on the Berks & Hants route.

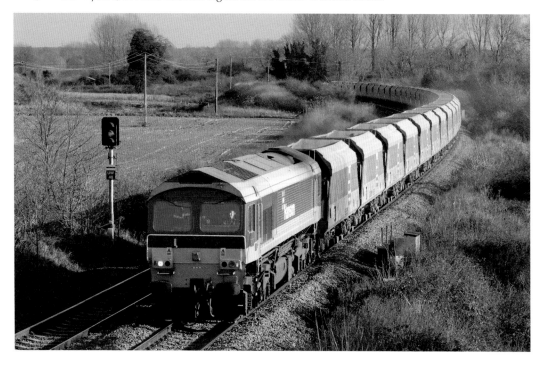

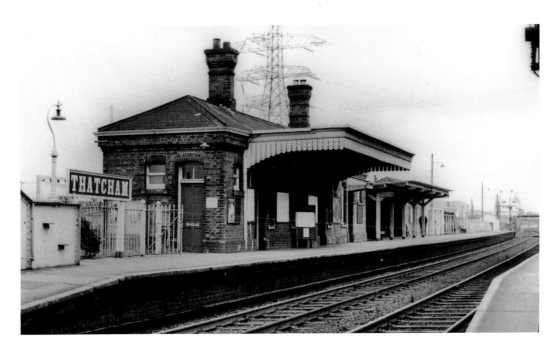

Thatcham

Continuing their long, but gradual ascent towards Savernake summit, down trains continue westwards to Thatcham, the next stopping place (49 miles 45 chains), which is approached on a ruling gradient of 1 in 326. This station boasted a standard Great Western station building on the up platform. The platforms were linked by a plate girder footbridge, and the goods yard could handle coal, livestock and other forms of traffic. The upper picture shows the station building around 1965, while the lower photograph is looking westwards around 1973.

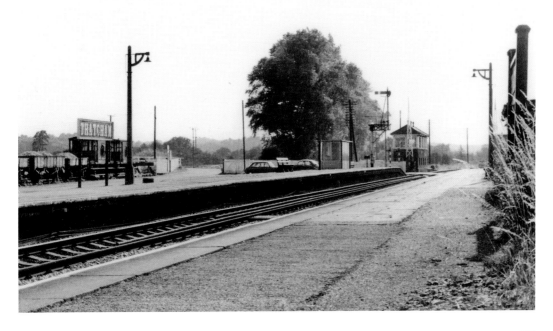

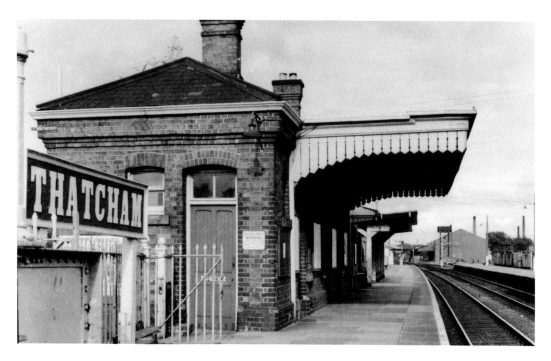

Thatcham

Above: The brick-built station building contained the usual booking office and waiting room accommodation, together with toilets for both sexes. Although Thatcham is still staffed, the GWR station building has been replaced by modern buildings, and the goods yard was closed in 1970.
Below: The signal box was sited to the west of the platforms on the down side, in convenient proximity to the level crossing. It has now been closed, and the crossing is worked from nearby Calthrop crossing box with the aid of closed-circuit television.

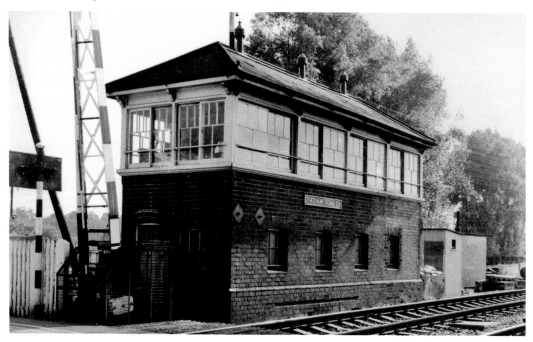

Newbury Racecourse

Above: Newbury Racecourse station, some 3 miles beyond Thatcham, was opened on 26 September 1905 to serve the adjacent racecourse and, as such, it was used only for race traffic – special trains being run for the benefit of race-goers, who were carried almost to the gates of the famous racecourse. *Below*: Class '59' locomotive No. 59103 *Village of Mells* passes Newbury Racecourse with an empty stone train on 25 June 1999. In May 1988, the racecourse station became a calling point for local stopping services.

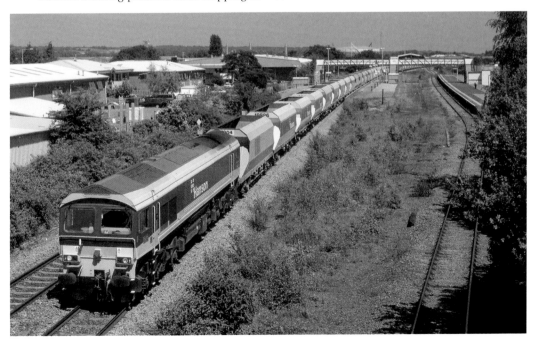

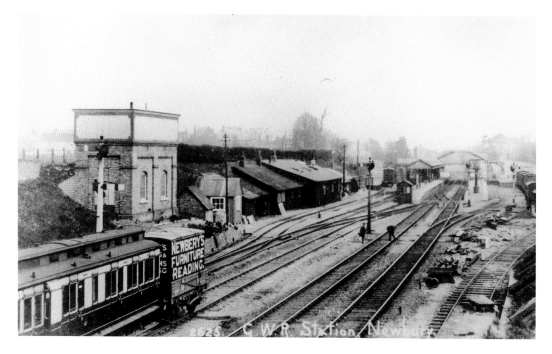

Newbury: The Original Station

Opened on 21 December 1847, Newbury (53 miles 7 chains) was the most important station on the original section of the Berks & Hants route. Its importance was further enhanced by the opening of the Didcot, Newbury & Southampton line, which was opened from Didcot to Newbury on 13 April 1882, and extended from Newbury to Winchester on 1 May 1885. The pictures show the original station, with its somewhat cramped layout, at the end of the Victorian period.

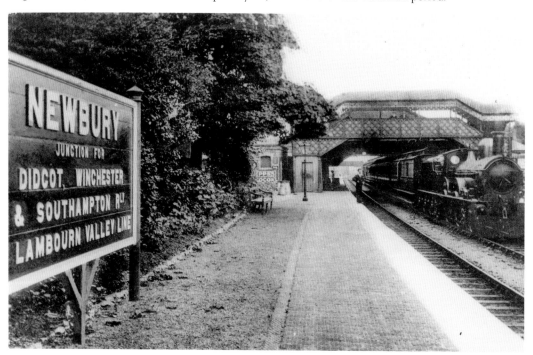

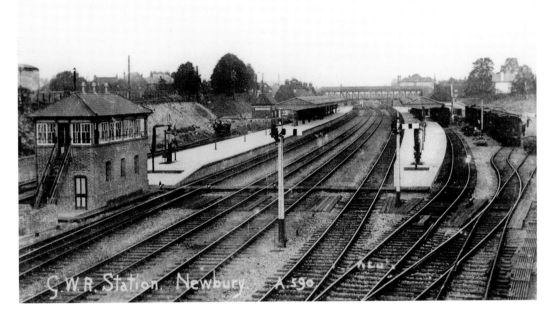

Newbury: The Remodelled Station

In addition to its role as a junction for the DN&S route, Newbury was also the starting point for the Lambourn branch, which was opened in 1898, thereby bringing further traffic to an already congested station. It was, in consequence, decided that Newbury would be rebuilt with much longer platforms and a spacious, quadruple-track layout; these new facilities were completed in 1912. The upper picture shows the newly rebuilt station from the road overbridge, while the lower view is looking eastwards along the down platform.

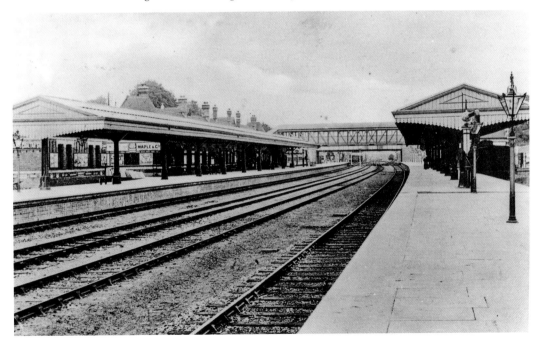

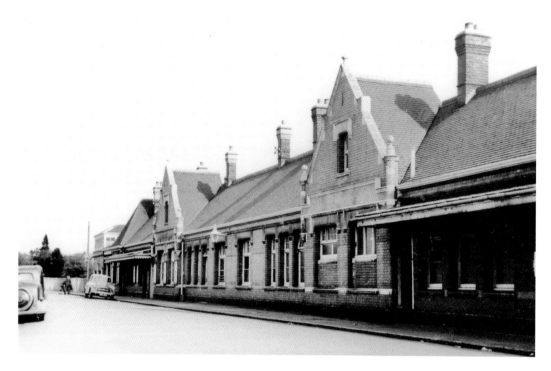

Newbury: The Station Buildings

The most noteworthy features of the remodelled station were the brick-built station buildings, which were deluxe versions of the Great Western's standard station design. The upper view shows the up-side station building from the station approach on 13 April 1959, while the lower picture provides a detailed look at the fully enclosed footbridge. The up-side building features prominent gables and decorative lintels, together with French chateau-style turrets at each end, while the down-side building is slightly smaller, and has no end turrets.

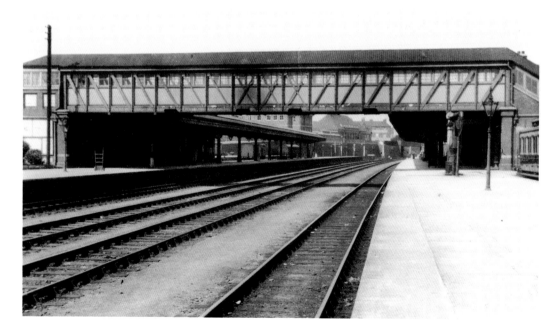

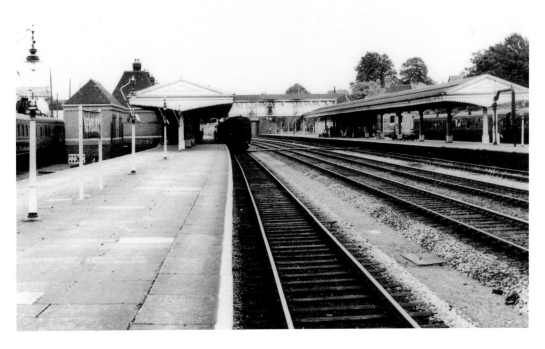

Newbury: Platform Scenes

Above: A general view of the station, looking east towards Paddington during the 1960s. The platforms were, at that time, numbered from 1 to 5 – platforms 1 and 5 being the up and down main lines respectively, while platforms 2, 3 and 4 were terminal bays. *Below*: A detailed view showing the underside of the canopy at the west end of the up platform. Platform 3, to the right of the picture, was used by Lambourn branch trains until the closure of the Lambourn line in 1960.

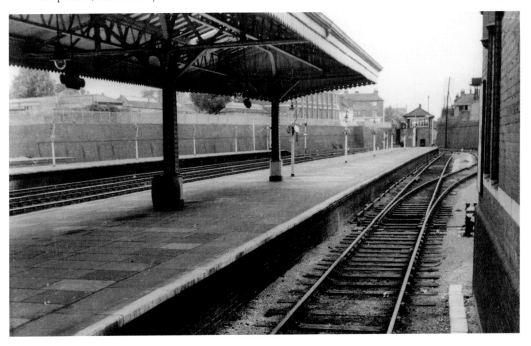

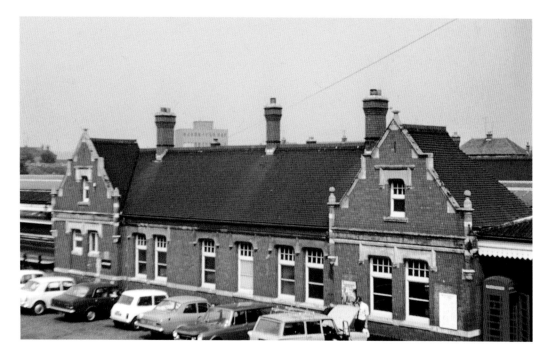

Newbury: A Busy Station

Above: The down-side station buildings in August 1973. Newbury has always been relatively busy in terms of passenger traffic. In 1962, for example, the station issued 134,000 tickets and 750 seasons, while 135,000 parcels were forwarded or received. In addition, the racecourse station handled approximately 3,000 passengers per annum. The staffing establishment at that time comprised eleven clerks, two supervisors and seventy-two other grades under the control of stationmaster R. Cox. *Below*: A 'Castle' class 4-6-0 speeds through Newbury with the Cornish Riviera Express.

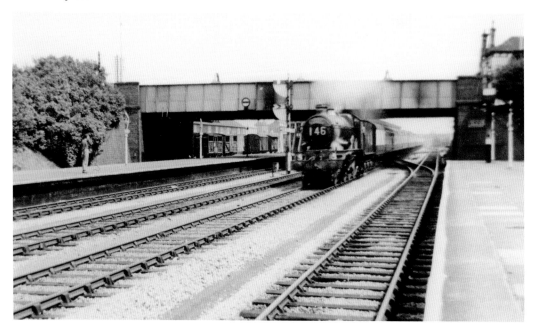

Newbury: Steam Locomotives at Work

Above: An unidentified 'County' class 4-4-2T locomotive stands in the platforms at Newbury with a main line stopping train. *Below*: Former Midland & South Western Junction Railway 2-4-0 locomotive No. 1335 (formerly M&SWJR No. 11) stands alongside the down platform at Newbury with a Lambourn branch freight working. This veteran locomotive was built by Messrs Dübs & Co. of Glasgow in 1894, and it worked on the Lambourn Valley line until its withdrawal from regular service in 1952.

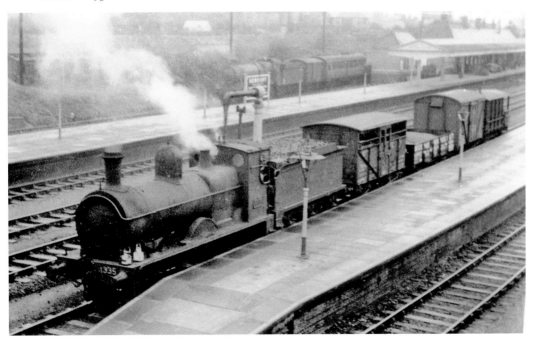

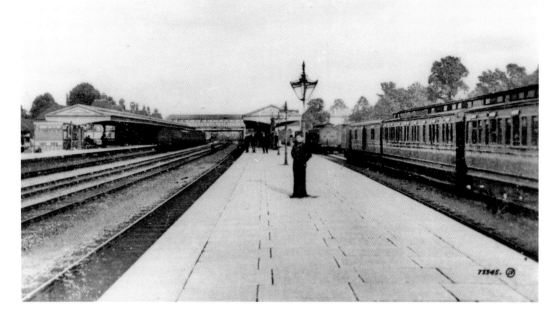

Newbury

Above: An Edwardian postcard scene, looking east towards Paddington. *Below*: A selection of tickets issued in the Newbury area during the British Railways period, including an undated platform ticket, a staff 'privilege ticket', and an Edmondson card single from Newbury to Kintbury that was issued on 17 February 1970. The three vertical tickets are old-fashioned railmotor-style paper tickets, which were still being issued by conductor guards on the Berks & Hants route in the summer of 1970.

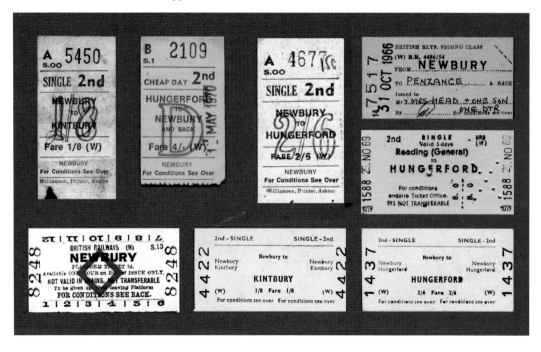

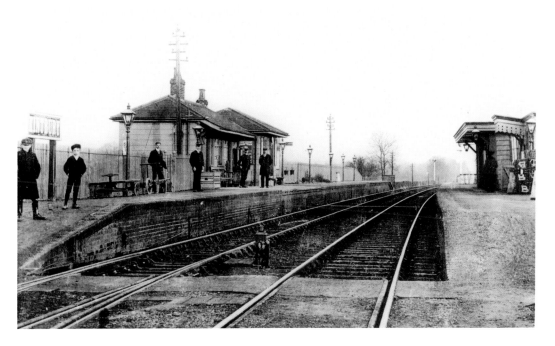

Kintbury: The Station Buildings

Leaving Newbury, trains climb westwards on gently rising gradients, with Kintbury, 58 miles 38 chains from Paddington, being approached on a ruling gradient of 1 in 288. Up and down platforms were provided here, with a modest goods yard on the down side. The station was equipped with an accretion of ramshackle wooden buildings that, from their appearance, probably dated back to the 1840s. The upper picture shows the up platform around 1912, while the lower photograph was taken from a similar vantage point around 1963.

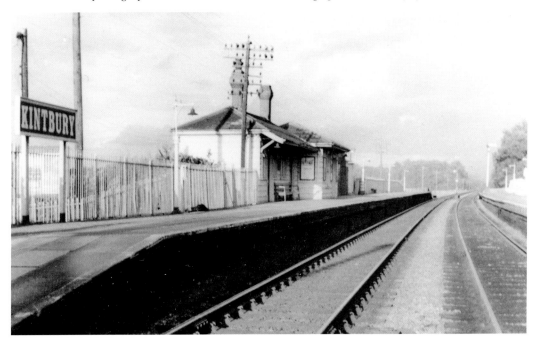

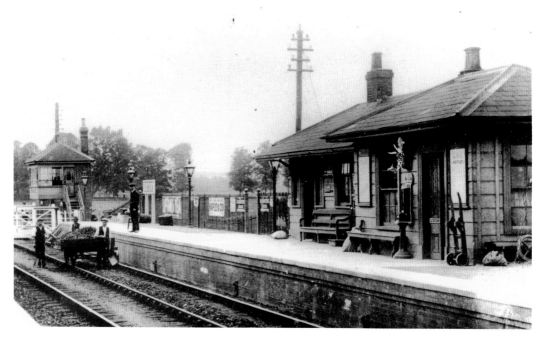

Kintbury: Steam Age Infrastructure

The upper picture is a detailed view of the main, up-side buildings during the Edwardian era, with the level crossing and signal cabin visible in the distance. The signal box was opened in 1877 and, as originally built, it featured a hipped roof and small-paned windows. However, in 1947, the building was rebuilt with new windows and a gabled roof, as shown in the lower illustration; the box was originally fitted with a 16-lever frame, but this was replaced by a 20-lever frame in 1912.

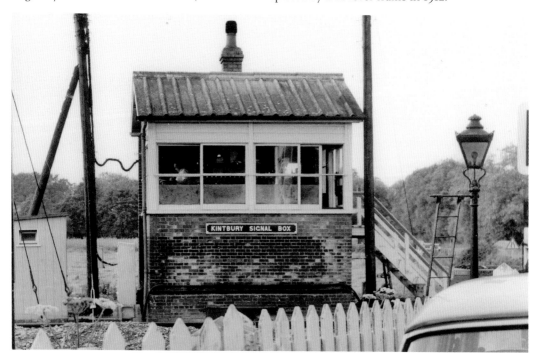

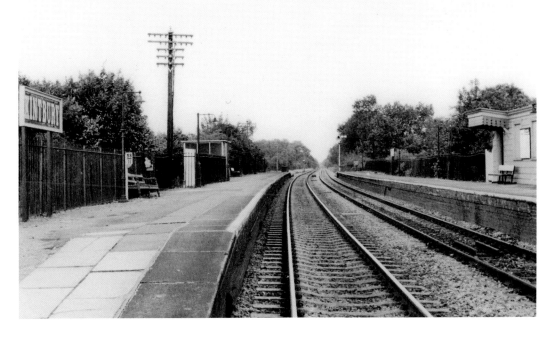

Kintbury: After Rationalisation

Above: Kintbury in the 1970s, looking east towards Paddington after removal of the main station building. The bus stop-style waiting shelter that can be seen in this picture has now been replaced by a more substantial, brick-built structure. *Below*: HST power car No. 43129 passes Kintbury with the 1.05 p.m. Paddington to Plymouth service on 2 April 2007. This photograph was taken from the Kennet & Avon Canal, which runs parallel to the railway for over 30 miles between Reading and Pewsey.

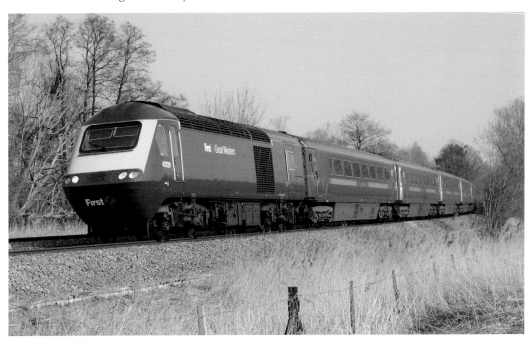

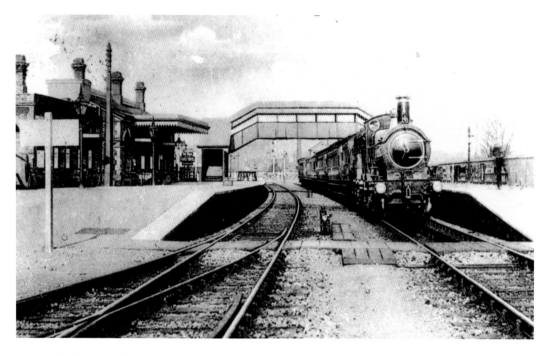

Hungerford: Edwardian Postcard Views

From Kintbury, trains continue along the Kennet Valley, with the Kennet & Avon Canal still clearly visible on the left-hand side of the line. Hungerford (61 miles 43 chains), the original terminus of the Berks & Hants Railway, was reconstructed on a new alignment when the route was extended to Devizes in 1862, and this may explain the curious position of the main station building, which is sited at an angle to the running lines, as revealed in these Edwardian postcard scenes.

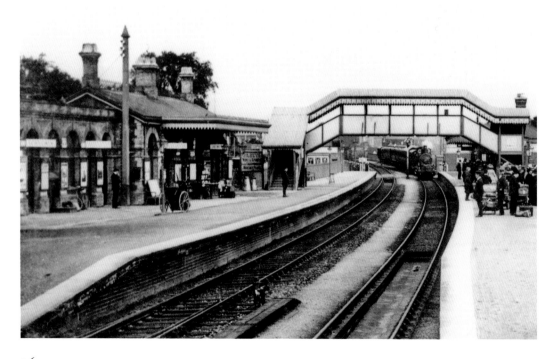

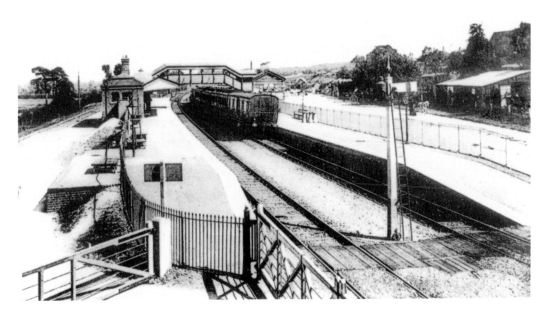

Hungerford: Destructive Incidents

On Monday 18 November 1867, *The Times* reported that Hungerford's 'up station and adjoining buildings, which were principally of wood' had been destroyed by fire on the previous Saturday, although the down-side building was saved by the exertions of the local fire brigade. The upper picture shows the down platform around 1912, while the lower view depicts the modern signal box that was erected by BR after the Great Western cabin had been destroyed by a derailed stone train on 10 November 1971.

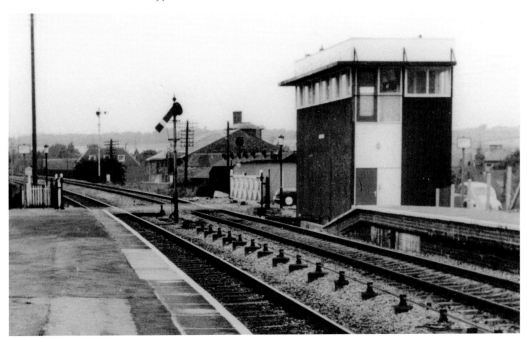

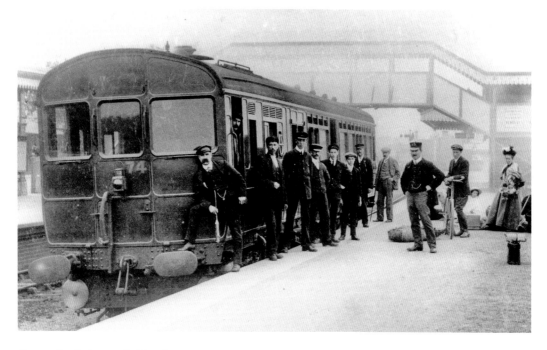

Hungerford: Steam & Diesel Power

The upper view shows GWR steam railmotor car No. 74 alongside the up platform, around 1906. Car No. 74 was one of a batch of eight railmotors, numbered from 73 to 80, placed in service in that year. These self-propelled vehicles were the ancestors of today's multiple unit trains, such as First Great Western class '166' three-car unit No. 166218, which is seen near Hungerford in the lower view while forming the 8.37 a.m. Bedwyn to Paddington service on 30 July 2007.

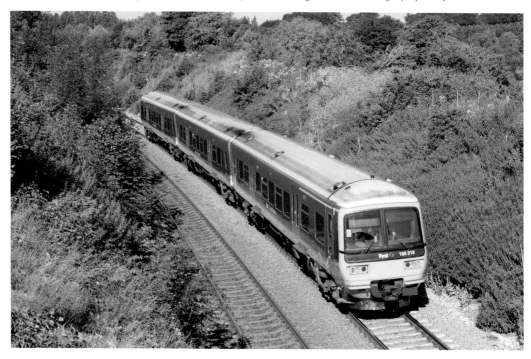

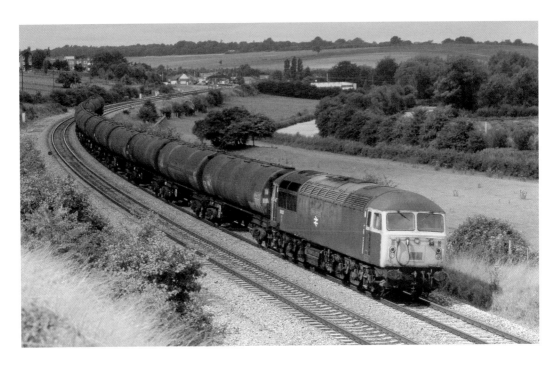

Hungerford: Bulk Freight Traffic

Above: Class '56' locomotive No. 56037 *Richard Trevithick* rounds the curves near Hungerford while working the 5.00 a.m. Robeston to Theale oil train on 3 September 1984; Hungerford station is visible in the distance, while the Kennet & Avon Canal can be glimpsed to the right. *Below*: Class '59' locomotive No. 59004 *Paul A. Hammond* approaches Hungerford at the head of the 7.12 a.m. Merehead to Acton Yard stone train on 30 July 2007.

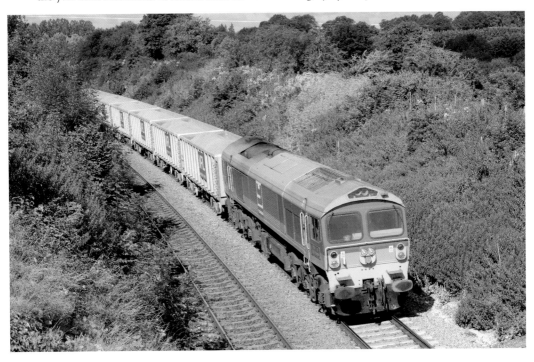

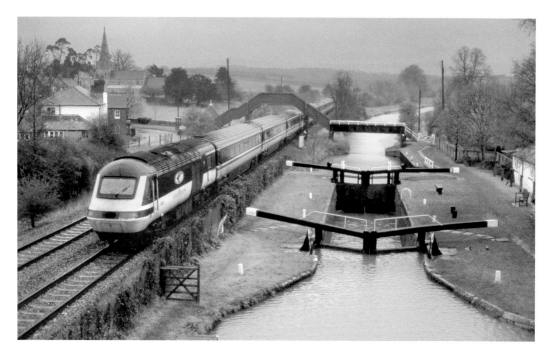

Bedwyn: The Kennett & Avon Canal

Having left Hungerford, trains run south-westwards for a little under 5 miles as they climb towards Bedwyn crossing, en route, the county boundary between Berkshire and Wiltshire. The upper photograph shows HST power car No. 43011 beside the canal at Little Bedwyn on 23 April 1998 while working the 12.35 p.m. Paddington to Penzance service. Sadly, No. 43011 was badly damaged in the Ladbrooke Grove crash on 5 October 1999, and the vehicle was subsequently scrapped. The lower view shows No. 43016 at the same location on 25 June 2010.

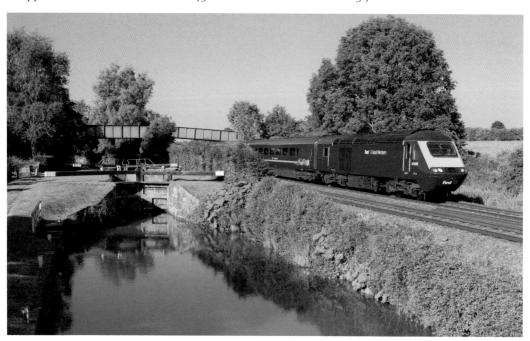

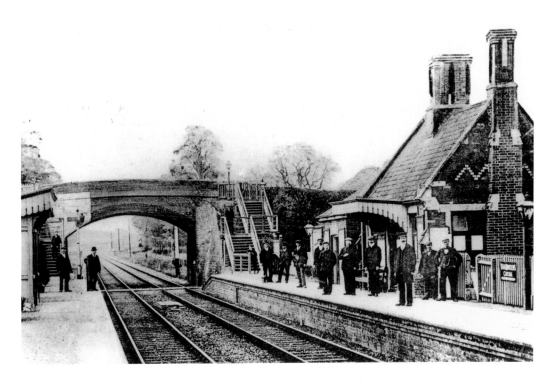

Bedwyn: Victorian Architecture

Bedwyn station, some 66 miles 33 chains from Paddington, was opened in 1862, and its ornate, Tudor-style station building, which was situated on the up platform, reflected architectural practice on the Berks & Hants Extension Railway. This distinctive structure was of brick construction, with decorative, diaper-patterned brickwork, and a steeply pitched gable roof. Buildings of this type were also erected at Savernake, Pewsey and Woodborough stations.

The upper picture shows the station building and road bridge during the early years of the twentieth century, while the lower view is looking eastwards from the road overbridge, probably around 1925. The 1938 Railway Clearing House *Handbook of Stations* reveals that the modest goods yard, which can be seen in the distance, was able to handle coal, livestock, horseboxes and general merchandise traffic, while a 3-ton yard crane was available for handling large or bulky consignments. Goods facilities were withdrawn in September 1964.

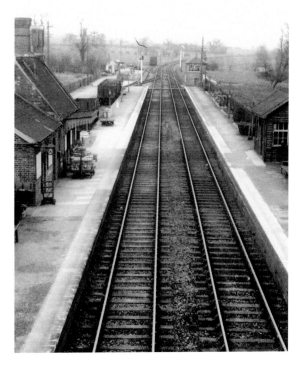

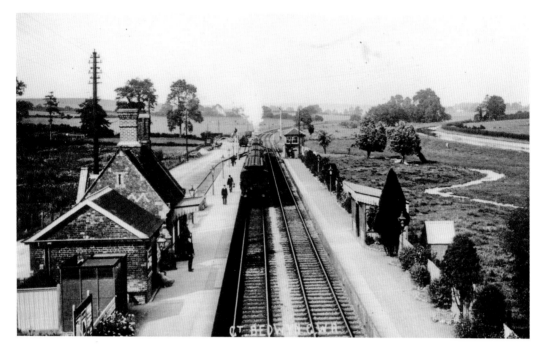

Bedwyn: The Final Locomotive-Hauled Local Service

Above: A general view of Bedwyn station, looking eastwards from the road overbridge around 1912. *Below*: This colour photograph shows a fourteen-coach special train, which was run on 3 July 1992 to mark the end of 'Network SouthEast' locomotive-hauled services on the Berks & Hants route. The train, which ran from Paddington to Westbury and was hauled by class '47' locomotive No. 47701 *Old Oak Common Traction & Rolling Stock Depot* and sister engine No. 47423, is pictured arriving at Bedwyn in appropriately funereal weather.

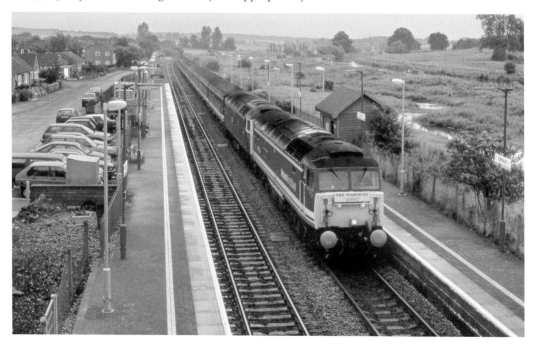

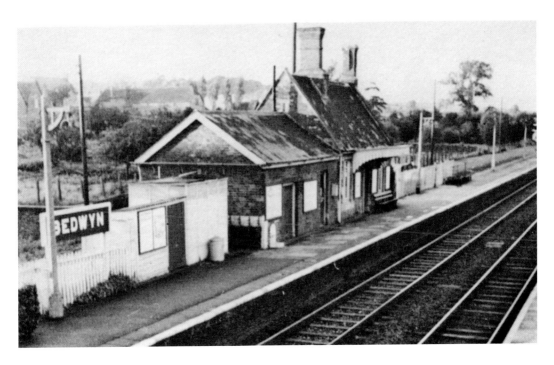

Bedwyn: Then & Now

The upper picture provides a further glimpse of the station building from the road overbridge during the 1960s, while the colour photograph was taken from the same vantage point in 2008; the Victorian building has been replaced by a simple bus stop-style shelter, although more substantial wooden shelter is available on the down side. Class '165' unit No. 165112, which can be seen in the picture, has just arrived with a down service from Paddington.

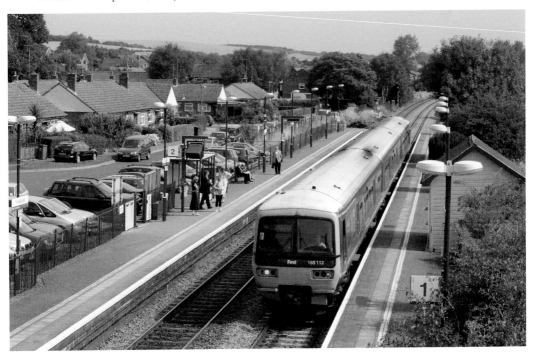

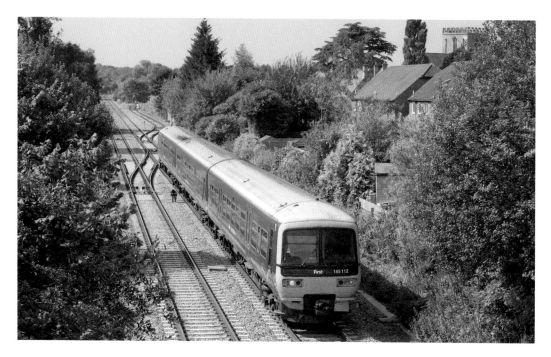

Bedwyn: Steam & Diesel Motive Power

Above: Class '165' unit No. 165112 pulls out of the reversing siding that can be seen in the background and moves slowly forward into Bedwyn station, where it will form the 10.37 a.m. First Great Western service to Paddington; the unit had arrived in Bedwyn as the 9.18 a.m. down service from Paddington. *Below*: Stanier 'Black Five' 4-6-0 No. 44871 and Southern 'N15' class 4-6-0 No. 30777 *Sir Lamiel* approach Great Bedwyn on 22 May 2010 while hauling the Railway Touring Company 'Royal Wessex' railtour from Paddington to Weymouth.

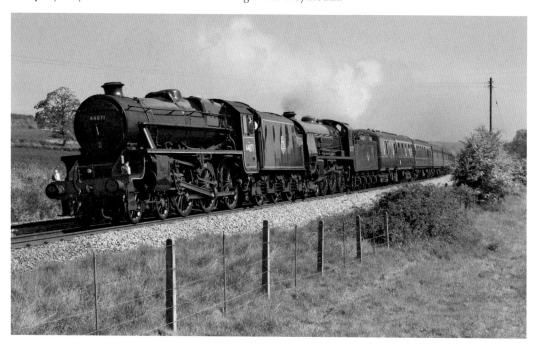

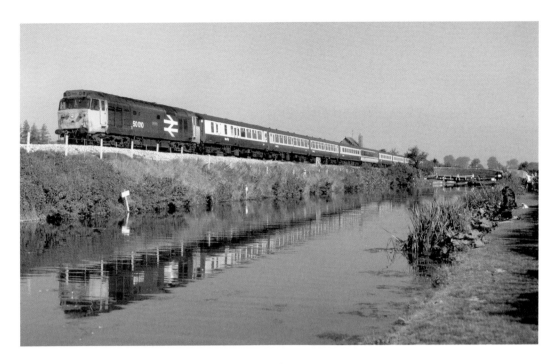

Savernake: Beside the Kennet & Avon Canal

As trains approach the abandoned station at Savernake, they pass Crofton Pumping Station, which supplies water to the summit level of the Kennet & Avon Canal. The upper view shows class '50' locomotive No. 50010 *Monarch* beside the canal at Crofton, while working the 11.00 a.m. Paddington to Paignton service on 23 September 1986. The lower picture shows class '60' locomotive No. 60015 *Bow Fell* passing Crofton with the 9.33 p.m. Robeston to Theale oil train on 21 July 2006.

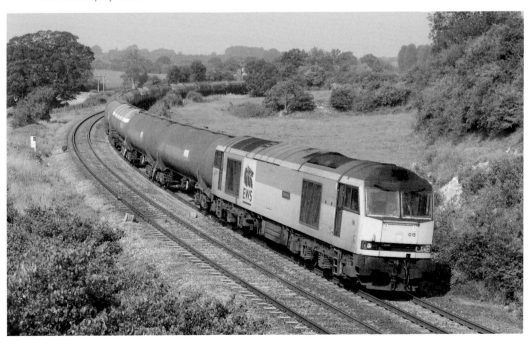

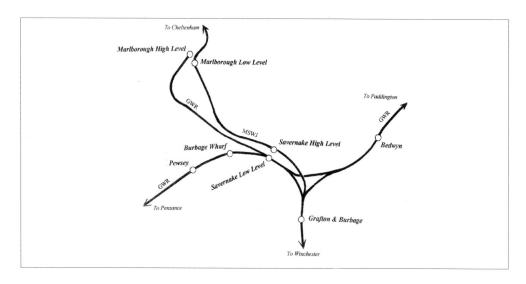

Savernake: Wolfhall Junction and the Midland & South Western Junction Railway

Situated at the summit of the line, Savernake (70 miles 8 chains) was opened in 1862 as a single-platform station, but a bay was installed at its western end to serve the Marlborough branch, which was opened on 14 April 1864. A few years later, in the early 1870s, a company known as the Swindon, Marlborough & Andover Railway was formed with the aim of constructing a 12-mile line between Marlborough and Swindon. At Marlborough, the line would join the branch from Savernake, while a separate section of line would run southwards from Wolfhall, near Savernake, to reach the London & South Western Railway at Andover.

Trains began running between Swindon and Marlborough on 26 July 1881, and the southern portion of the line came into use on 1 May 1882 – although through running over the intervening Marlborough branch did not commence until 5 February 1883. In the meantime, a separate undertaking known as the Swindon & Cheltenham Extension Railway had been incorporated, with powers for the construction of a northwards link between Rushey Platt, near Swindon, and the Banbury & Cheltenham Direct Railway at Andoversford. Although the Swindon & Cheltenham

Extension Railway was a nominally independent concern, it was intimately connected with the Swindon, Marlborough & Andover company, and in 1884 the two undertakings were formally merged to create the Midland & South Western Junction Railway.

After a period of financial difficulties, the M&SWJR developed into a useful cross-country link between Cheltenham, Andover and Southampton – access to the latter destination being secured by means of running powers over the L&SWR. On 26 June 1898, the M&SWJR opened an avoiding line between Marlborough and Wolfhall Junction, which bypassed the Marlborough branch and the GWR station at Savernake.

As a result of these developments, the junctions and other railway infrastructure around Savernake became surprisingly complicated, with separate GWR and M&SWJR stations at Savernake and Marlborough, as shown in the accompanying sketch map. The colour photograph shows class '50' locomotive No. 50010 *Monarch* at the site of Wolfhall Junction in 1985.

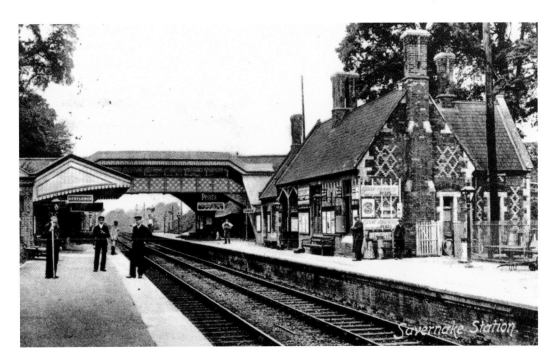

Savernake: The Low Level Station

Above: Savernake Station, looking west during the 1960s, with the distinctive station building to the right. The down platform, which can be seen on the left, was installed after the opening of the Swindon, Marlborough & Andover line. *Below*: Looking westwards from the road bridge, probably around 1928. The bay platform, which can be seen in the foreground, had no run-round facilities and, as a result, incoming branch trains had to draw forward onto the branch in order to run-round.

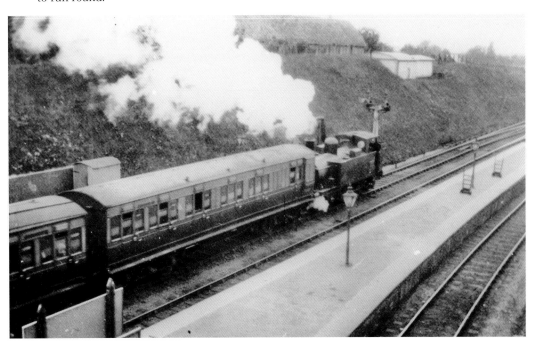

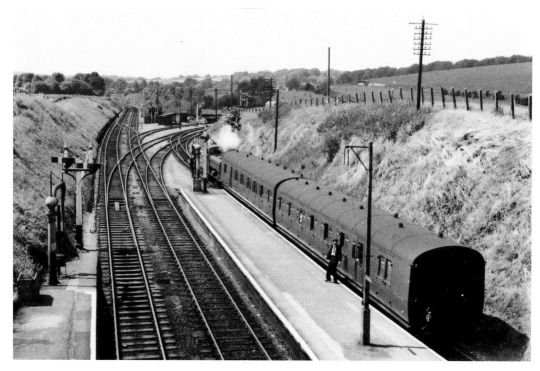

Savernake: Rationalisation of the System

The Midland & South Western Railway was amalgamated with the GWR in 1923 under the provisions of the Railways Act 1921, and in the following year the M&SWJR and GWR stations at Savernake were renamed 'Savernake High Level' and 'Savernake Low Level' respectively. The GWR station at Marlborough was closed in 1933 as part of a rationalisation programme, but the two Savernake stations remained in use until 1958, when Savernake High Level station was closed, and M&SWJR services were diverted into Savernake Low Level.

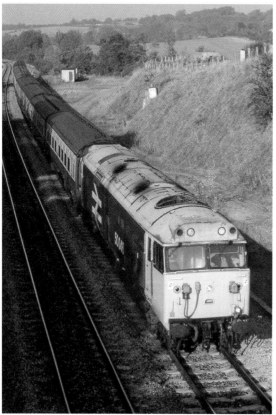

The last trains ran between Swindon, Savernake and Andover on Sunday 10 September 1961, while Savernake Low Level station was itself closed on 16 April 1966. The upper picture shows a local train in the branch platform around 1962, while the colour photograph shows class '50' locomotive No. 50046 *Ajax* passing through the abandoned Low Level station with an up express in 1983.

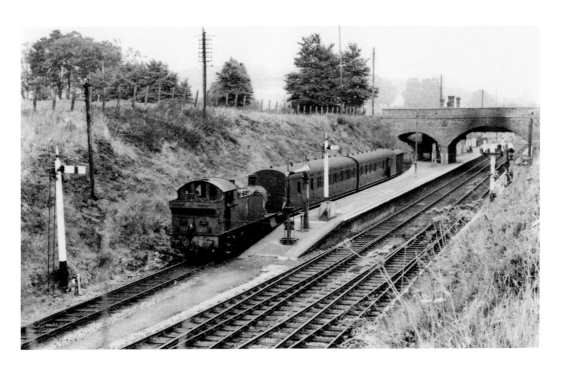

Savernake: The High and Low Level Stations

Above: An unidentified '45XX' class 2-6-2T stands in the bay platform at Savernake Low Level with a two-coach branch train during the 1950s. There were, at that time, around half-a-dozen trains each way between Savernake Low Level and Marlborough. *Below*: A glimpse of the former Midland & South Western Junction station at Savernake High Level, which was closed officially in 1959, although trains had stopped running in the previous year. The southbound platform, seen on the left, was being used for wagon storage.

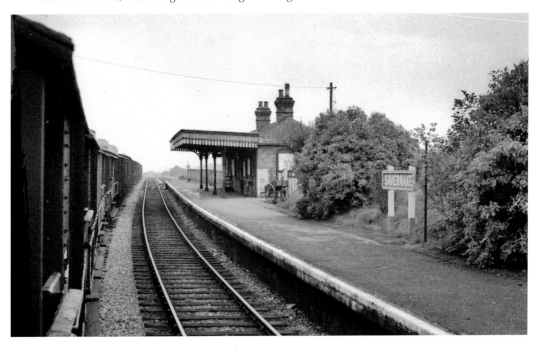

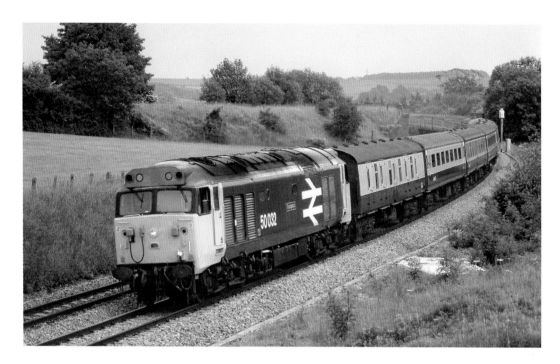

Savernake: Trains at Wolfhall Junction

Above: Class '50' locomotive No. 50032 *Courageous* passes the site of Wolfhall Junction as it approaches Savernake with the 1.40 p.m. Paddington to Penzance service on 2 July 1985. The abutments of the girder bridge that once carried the M&SWJR line over the Berks & Hants Extension route can be seen in the background. *Below*: Photographed on the same day, class '56' locomotive No. 56050 passes Wolfhall with the 10.05 a.m. Acton to Merehead Foster Yeoman stone empties on 2 July 1985.

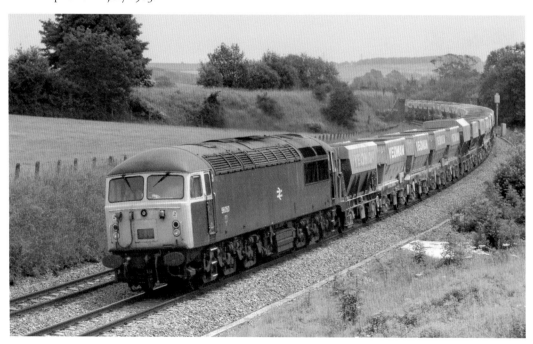

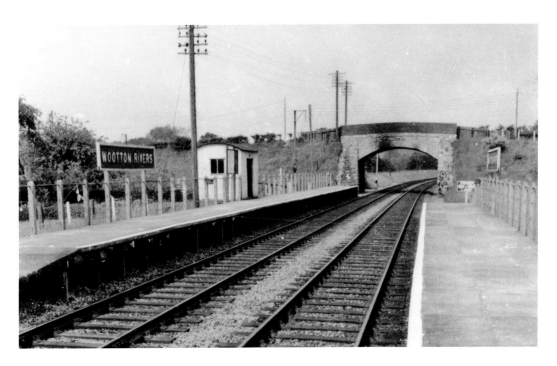

Wootton Rivers Halt

Having surmounted its summit, the Berks & Hants Extension line drops towards Wootton Rivers Halt (72 miles 43 chains) passing, en route, the site of a now-closed goods station at Burbage. Opened by the GWR on 24 September 1928, Wootton Rivers was an unstaffed halt with concrete platforms and corrugated iron shelters; it was closed in April 1966. *Below*: Class '59' locomotives Nos 59001 *Yeoman Endeavour* and 59202 *Vale of White Horse* pass Wootton Rivers with an empty stone train on 24 April 2009.

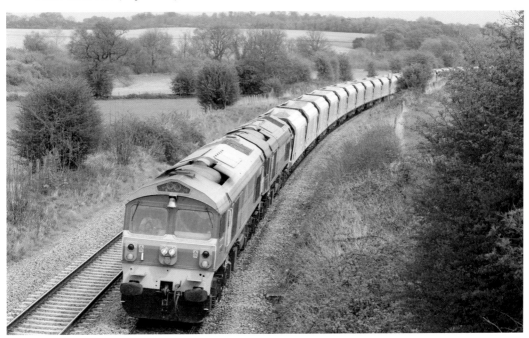

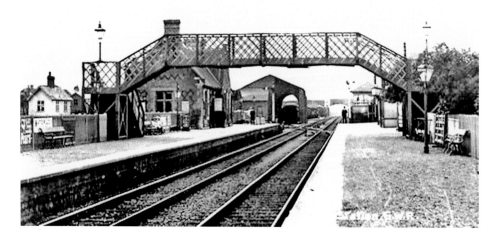

Pewsey

Speeding south-westwards, down trains approach Pewsey. The Kennet & Avon Canal can still be seen on the right-hand side of the line, although, having passed Wootton Rivers, the waterway finally parts company with the railway. Pewsey Station, 75 miles 26 chains from Paddington and 41 miles 28 chains from Reading, was opened on 11 November 1862. The upper view shows the station during the GWR period, while the lower picture shows class '59' locomotive No. 59102 *Village of Chantry* passing through this still-extant stopping place in 2013.

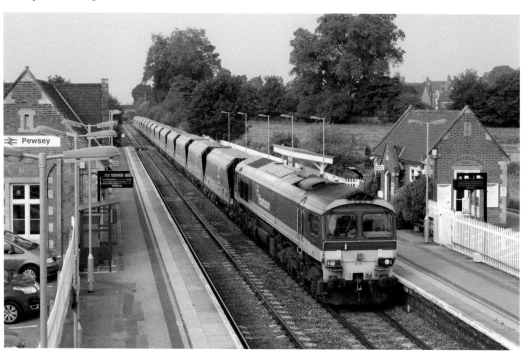

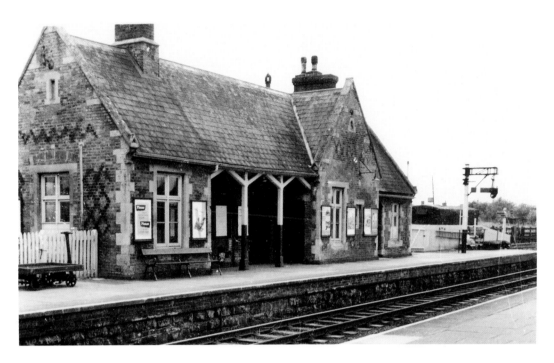

Pewsey: The Station Buildings

Until rationalisation, the track layout Pewsey had incorporated were up and down platforms for passenger traffic, with a goods yard on the down side. The yard sidings were connected to the running lines by trailing connections on each direction, while the signal box was sited to the west of the platforms on the up side. The upper picture, dating from around 1963, shows the Berks & Hants Extension Railway station building on the down platform, while the colour photograph shows the same building on 23 August 2013.

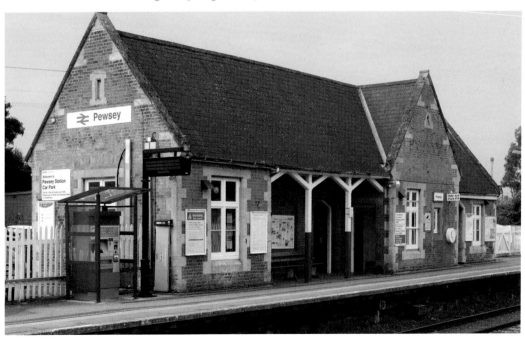

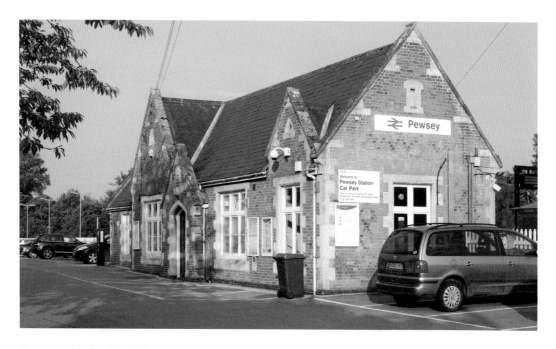

Pewsey: The Station Buildings

Above: A rear view of the main station building on 23 August 2013. Despite the loss of its chimney stacks, this picturesque Victorian structure is in excellent condition. *Below*: The up-side waiting room is a modern building that was built as recently as 1984 – the year of construction being proudly displayed on a date-stone above the door. A traditional style of architecture was adopted in order that this small but attractive structure would match the original building on the opposite platform.

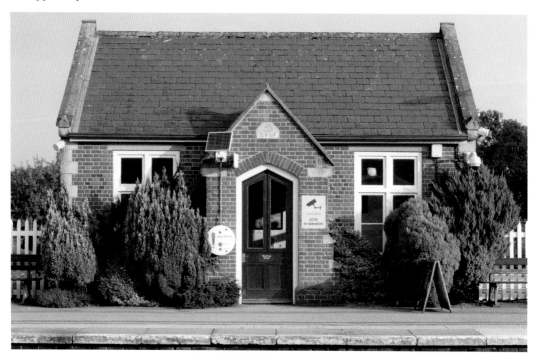

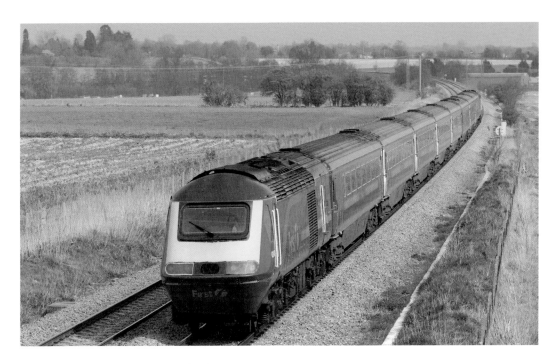

Pewsey: Passing Manningford Bruce

Above: HST power car No. 43040 *Bristol St Philip's Marsh* speeds past Manningford Bruce, to the west of Pewsey, while heading the 1.05 p.m. Paddington to Plymouth First Great Western service on 12 April 2007. *Below*: Class '66' locomotive No. 66707 *Sir Sam Fay* passes Manningford Bruce with the 6.34 a.m. Taunton (Fairwater Yard) to Peterborough working on 9 August 2007; the train was carrying scrap concrete sleepers.

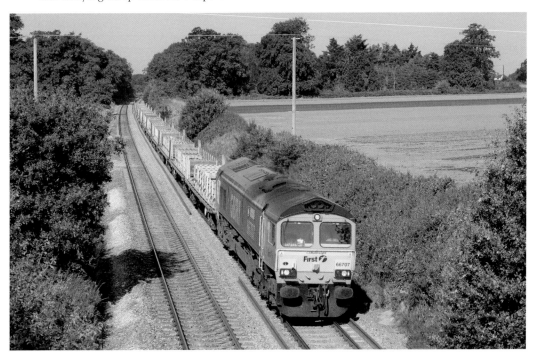

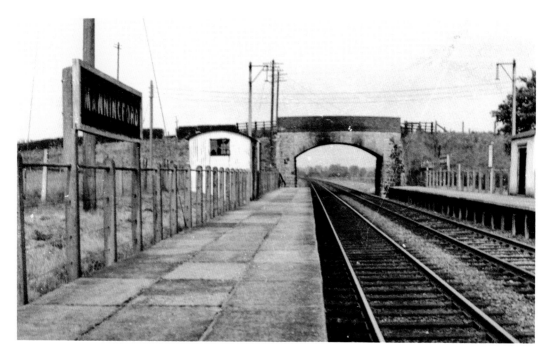

Manningford Halt

Manningford (76 miles 62 chains) was less than 1½ miles beyond Pewsey. Like Wootton Rivers, this simple, unstaffed halt was a relatively late addition to the railway network, having been opened on 20 June 1932 to serve the nearby villages of Manningford Abbots and Manningford Bruce. Its modest facilities comprised segmental concrete platforms and arc-roofed waiting shelters for the convenience of occasional travellers. The halt was closed, together with most of the other stations on this part of the line, on 16 April 1966.

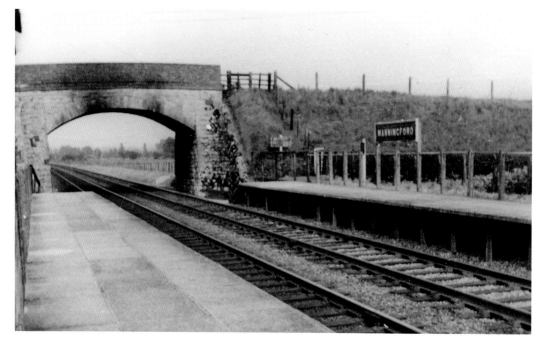

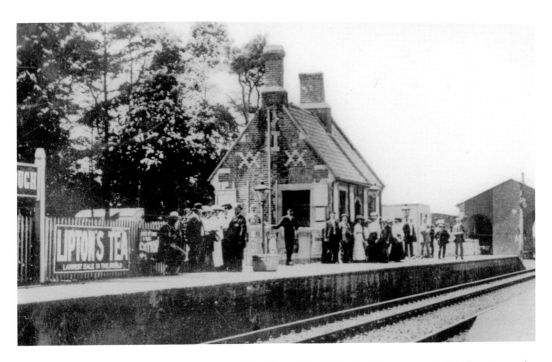

Woodborough

From Manningford, the line continues more or less due west towards the next stopping place at Woodborough. This station, which was 78 miles 69 chains from Paddington, was opened as part of the Berks & Hants Extension Railway in 1862. Its main station building was on the down side, as shown in this Edwardian postcard view. The goods yard, also on the down side, contained a goods shed, coal sidings and cattle loading pens, while two additional sidings were available on the up side of the line; these sidings were later modified to form goods loops.

The lower picture is looking east towards Paddington during the British Railways period. The single slip that can be seen in the foreground linked the up and down running lines, and provided a connection between the up main line and the goods yard sidings. Woodborough goods yard was closed in August 1966, just four months after the withdrawal of passenger services.

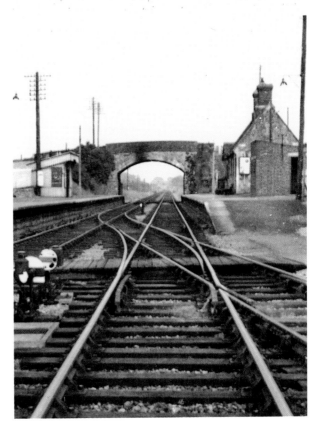

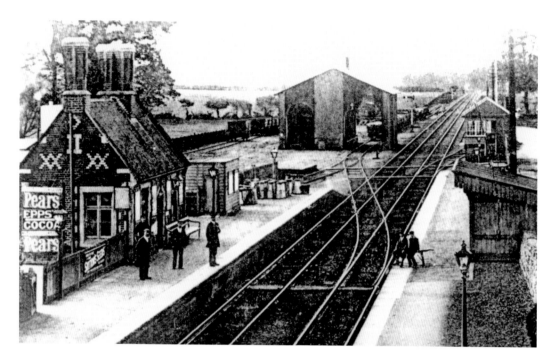

Woodborough

Above: A further glimpse of Woodborough station and goods shed during the early 1900s.
Below: This colour photograph was taken from a similar vantage point in 1984; it shows class
'59' locomotive No. 59001 *Yeoman Endeavour* pulling slowly out of Woodborough loop with a
3,000-ton loaded stone train from Merehead Quarry to Acton Yard. Although the station is now
defunct, the presence of up and down running loops at this point means that Woodborough is
still a place of considerable activity.

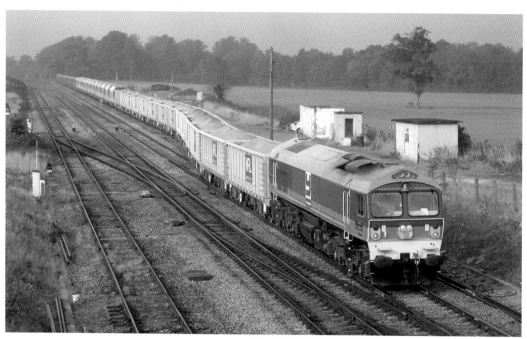

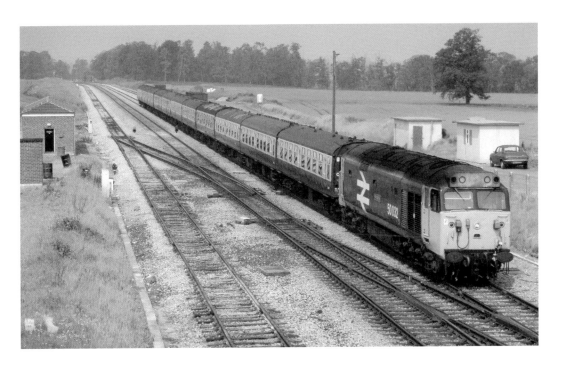

Woodborough

Above: Substituting for an HST set, class '50' locomotive No. 50032 *Courageous* rushes through Woodborough with the 7.25 a.m. Plymouth to Paddington service. Despite having only 2,700 hp to deal with eleven Mk1 coaches (as opposed to the HST's combined 4,500 hp with just seven coaches), the train was only twenty minutes late after nearly three hours of running. *Below*: Class '66' locomotive No. 66064 passes Woodborough with the diverted 9.48 a.m. Purfleet to Cardiff Tidal Sidings steel empties on 17 February 2001.

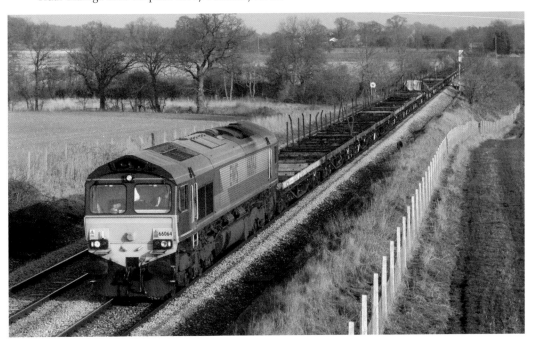

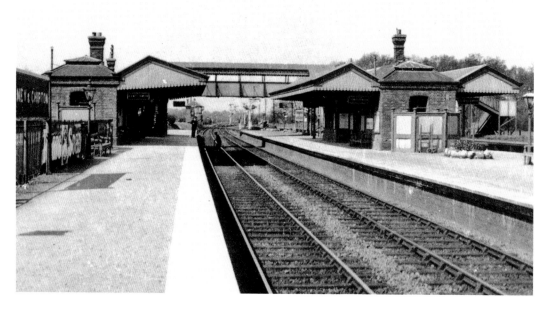

Patney & Chirton: Steam Age Infrastructure

Opened on 1 October 1900, Patney & Chirton (81 miles 7 chains) was the junction for the original Berks & Hants Extension route, which continued westwards beside the main line for about a mile before veering away to the right towards Devizes. Three platforms were available here, the up platform being an island with an additional face for Devizes branch services. The main station building, of standard GWR design, was on the down side, and there was a subsidiary building on the island platform.

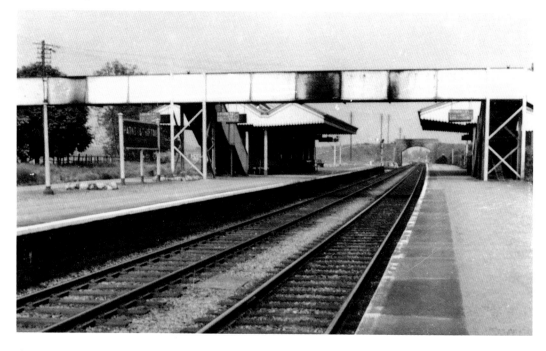

Patney & Chirton

The upper view shows the plate girder footbridge at the west end of the station. Although Patney & Chirton was closed in 1966, the footbridge still carries a little-used footpath across the railway, and this photograph of class '59' locomotive No. 59101 *Village of Whatley* heading the 7.12 a.m. Merehead to Acton Yard Yeoman 'jumbo' stone train was taken from the bridge on 9 August 2007. The trackbed of the abandoned Devizes line can be seen on the extreme right.

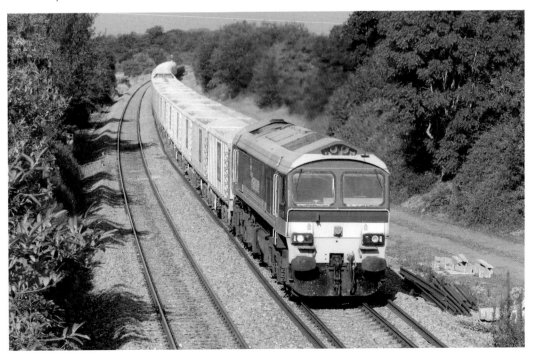

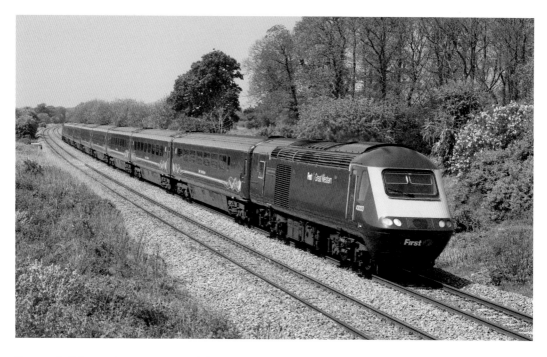

Patney & Chirton: Passenger & Freight Trains

Above: An HST set headed by power car No. 43003 *Isambard Kingdom Brunel* speeds past the site of Patney & Chirton station with the 8.42 a.m. Penzance to Paddington First Great Western service on 11 May 2009. *Below*: Class '59' locomotive No. 59206 *John F. Yeoman Rail Pioneer* plods slowly past the site of Patney & Chirton Station with the a Mendip Rail stone train from Whatley to West Drayton on 11 May 2009. No. 59206 had recently been repainted in DB Schenker red livery.

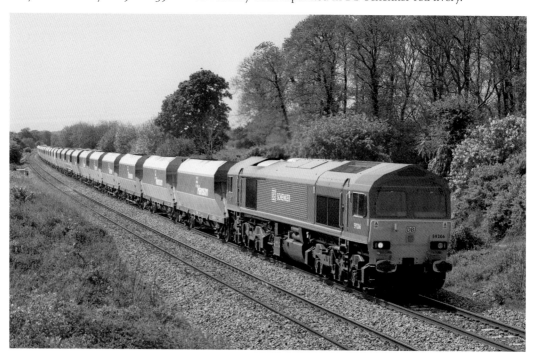

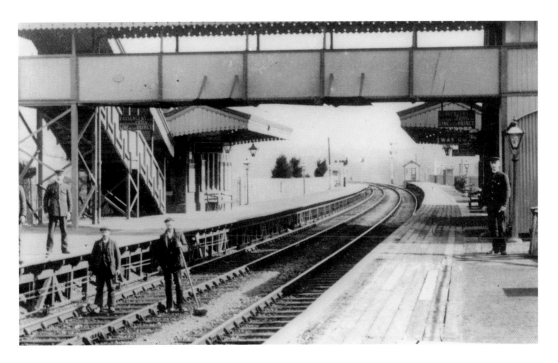

Lavington: Standard Great Western Buildings

Heading south-westwards along the superbly engineered 'cut-off', trains skirt the north face of the downs as they descend towards Lavington on a falling gradient of 1 in 222. Like its counterparts elsewhere on the West of England 'cut-off' lines, Lavington station (86 miles 72 chains) was equipped with red-brick buildings of standard Great Western design, together with a plate-girder footbridge and a hip-roofed signal cabin. The goods yard contained the usual coal wharves, cattle pens, loading docks and a 1½-ton yard crane.

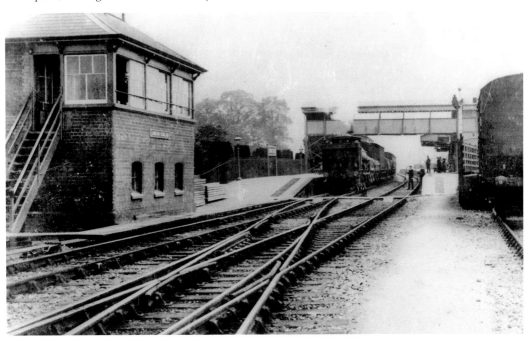

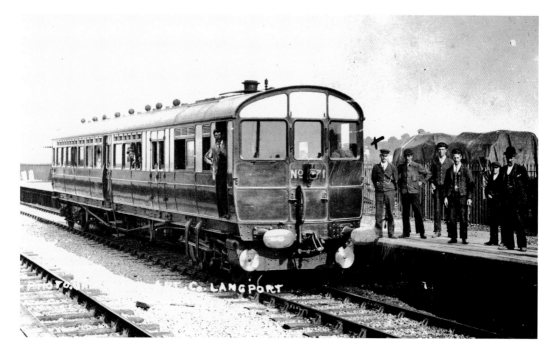

Lavington: Steam & Diesel

Above: Steam railmotor car No. 71 was one of a series of twelve vehicles, numbered from 61 to 71, which were built by Messrs Kerr Stewart & Co. in 1905. It is believed that this *c.* 1906 photograph was taken at Lavington (the word 'Langport' that can be seen in the centre of the picture is the photographer's address). *Below*: An HST set headed by power car No. 43016 sweeps round the curve at Great Cheverell, near Lavington, the 1.35 p.m. Paddington to Taunton service on 9 April 1999.

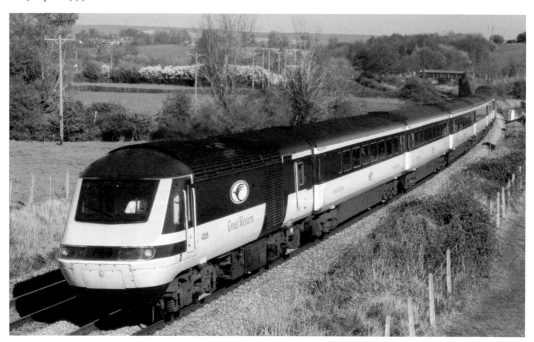

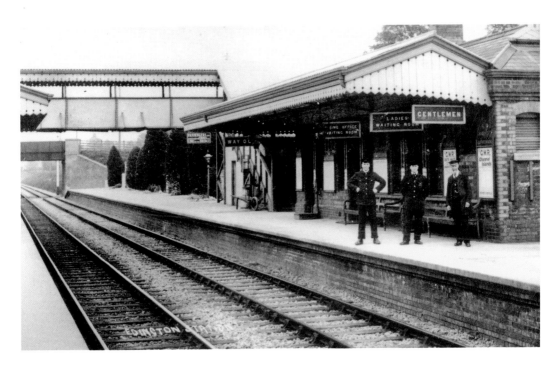

Edington & Bratton

Edington & Bratton (91 miles 32 chains) lost its passenger services in November 1952, although goods traffic was handled until 1967. This very rural stopping place served the villages of Edington, about half a mile to the south, and neighbouring Bratton, about 1½ miles from the railway; Edington was the scene of King Alfred's greatest victory over the Danes. The colour picture shows class '59' locomotive No. 59104 passing this long-closed station with a stone train on 18 April 1991. The former goods shed can be seen in the background.

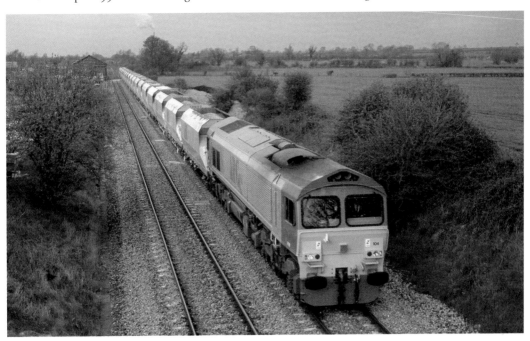

Edington & Bratton

The sepia photograph, which appears to have been taken from a signal post, provides a general view of the station, showing the up and down platforms and plate-girder footbridge. The colour photograph, in contrast, was taken from the road bridge on 11 March 1986, and it shows class '50' locomotive No. 50047 *Swiftsure* at the head of the 9.32 a.m. Penzance to Paddington service. Although, at first glance, the rear of the train appears to be on fire, the smoke is actually coming from fires on the side of the cutting that had been deliberately lit by permanent way men – a traditional method of clearing lineside vegetation that would be frowned upon by present-day health and safety zealots.

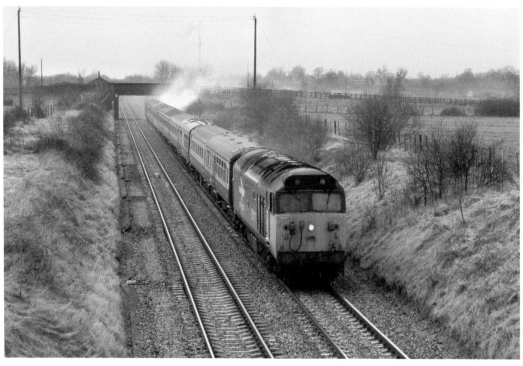

Westbury: The Passenger Station

Approaching Westbury (95 miles 46 chains), with the Westbury White Horse visible to the left, down trains reach Heywood Road Junction, where the Westbury avoiding line diverges from the Lavington 'cut-off'. Beyond, the main line continues towards Westbury station, where the 'cut-off' joins the Wilts, Somerset & Weymouth (WS&W) route.

Westbury station was reconstructed in connection with the West of England 'cut-off' scheme, the original Brunelian facilities being replaced by a new station with a spacious, twin-island layout, which was brought into use in 1900. The station is orientated on an approximate north-east to south-west alignment, with junctions at each end – the Paddington and Trowbridge routes diverging at the north end, while the Taunton and Salisbury lines bifurcate at the south end of the station. A minor road is carried across the line on a substantial plate girder bridge at the north end of the platforms.

The station is lavishly equipped with extensive buildings on both island platforms and, as might be expected, the station buildings are standard Great Western red-brick structures. The platforms are covered, for much of their length, by gable-roofed canopies with characteristic Great Western 'V-and-hole' fretwork valancing. The up and down platforms are linked by an underline subway, which is entered via a low-level booking office sited on the down side. The booking office is another typical GWR building, its architectural details being similar to those on the adjacent platform buildings.

The upper picture is looking northwards along the platforms towards the road overbridge, while the colour photograph shows Foster Yeoman class '59' locomotive No. 59003 at Fairwood Junction, to the south of the station, with a Merehead to Eastleigh stone train on 11 March 1986. Fairwood Junction is the point at which the Westbury avoiding line from Heywood Road Junction rejoins the main line.

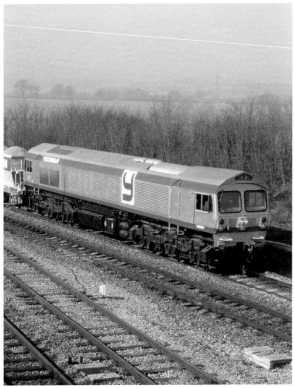

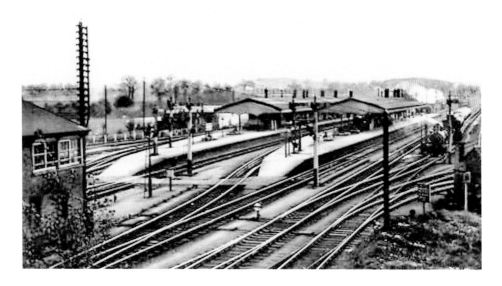

Westbury: Then & Now

Above: This Edwardian postcard is looking south-westwards from the road overbridge, the island platforms, with their standard Great Western buildings, being clearly visible, while Westbury north signal box can be seen on the extreme left. *Below*: The colour photograph, taken from a similar angle on 8 March 1986, shows Southern Region 6-car class '201' diesel multiple units Nos 1005 and 1007 leaving Westbury station with a Branch Line Society rail tour from Eastbourne to Merehead and Whatley quarries.

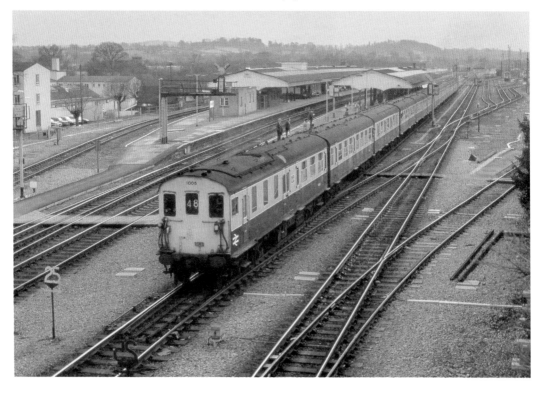

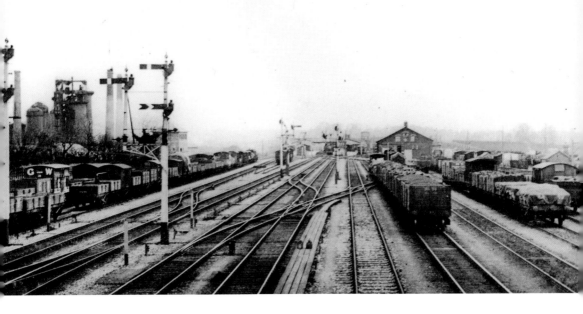

Westbury: Goods Facilities

Above: Westbury was lavishly equipped with goods facilities. The main goods yard was sited to the south-west of the passenger station, and it contained a gable-roofed goods shed with an 83-foot internal loading platform and a 150-foot external loading bank. In earlier years, a private siding connection on the up side of the running lines had served the extensive premises of the Westbury Iron Works. *Below*: The towering blast furnaces, which had dominated the station during the Victorian period, were closed around 1903, but the sidings remained in situ thereafter.

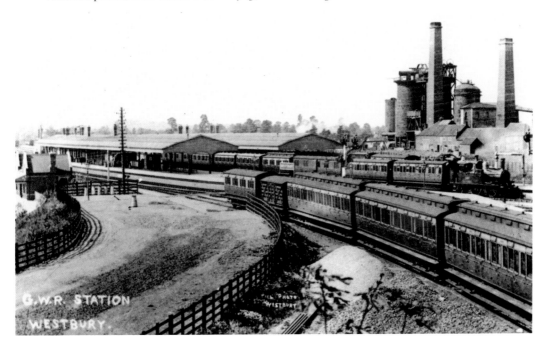

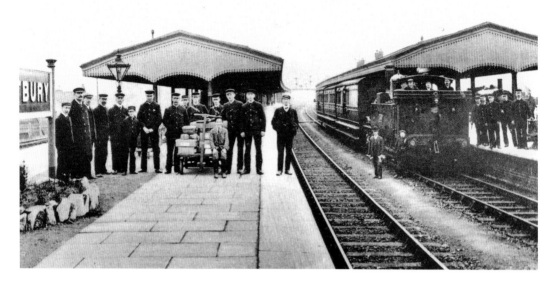

Westbury

The upper photograph shows the north end of the platforms during the early 1900s. A local passenger train, headed by a 2-4-0 'Metro Tank' can be seen to the right, while many of the GWR station staff have assembled on the platforms. The lower view, taken from a similar vantage point around 1962, reveals that very little had changed in the intervening fifty years, apart from the introduction of electric lighting.

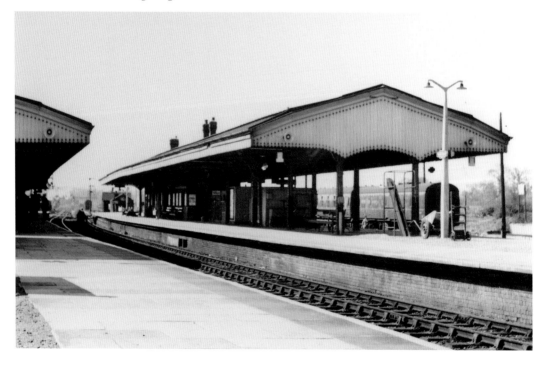

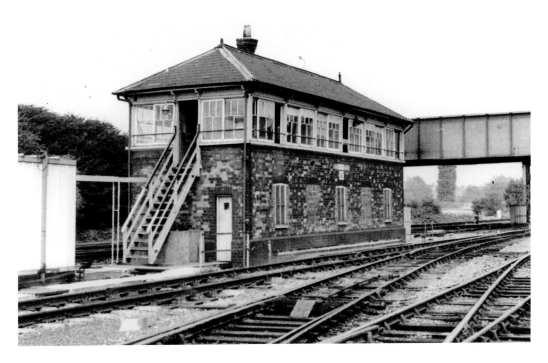

Westbury: The Signal Boxes

Above: In steam days, the station was signalled from three standard GWR signal cabins, which were designated 'Westbury North', 'Westbury Middle' and 'Westbury South' boxes. The upper picture shows Westbury North box, which was situated to the north of the platforms near the road overbridge. On 14 May 1984, these mechanical boxes were replaced by a new power box sited to the north of the road bridge on the down side. *Below*: Class '50' No. *50030 Repulse* passes Fairwood Junction with a Paddington to Paignton express on 11 March 1986.

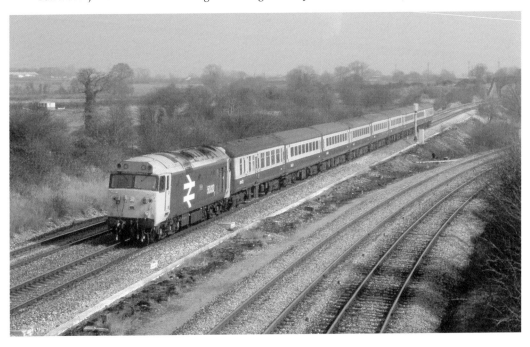

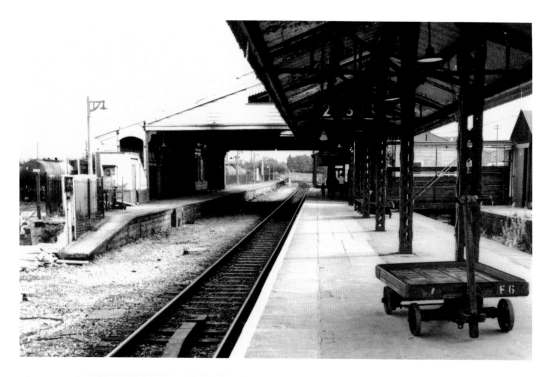

Frome: Wilts, Somerset & Weymouth Architecture

Having joined the Wilts, Somerset & Weymouth line at Westbury, trains proceed south-westwards along a section of the route that was opened on 7 October 1850. Entering Somerset, westbound trains soon reach Frome (101 miles 27 chains) – a relatively important station serving a prosperous market town that was once a centre of the woollen industry in the West of England.

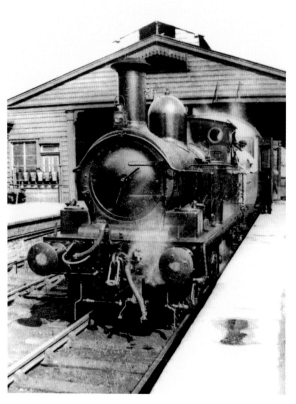

Observant travellers may note that the station architecture on the Wilts, Somerset & Weymouth line is entirely different to that encountered at the eastern end of the route – the differences being underlined, in the case of Frome, by the provision of a wooden train shed that formerly spanned the up and down lines, although all trains now use the former up line. The upper view, dating from the 1960s, is looking westwards along the surviving platform, while the lower photograph shows a '517' class 0-4-2T alongside the down platform, around 1925.

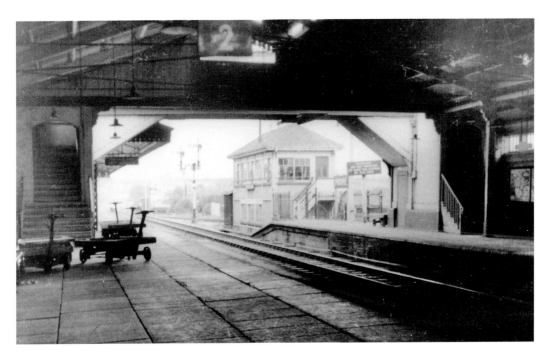

Frome: The 'Brunelian' Train Shed

Above: The interior of the train shed around 1960. Although often described as 'Brunelian' buildings, many of these smaller stations were probably designed by Brunel's assistants – albeit working from plans drawn-up by Brunel in the first instance. *Below*: Class '59' locomotives Nos 59004 *Paul A. Hammond* and 59103 *Village of Mells* stand alongside the remaining platform at Frome station with a Pathfinder Tours/Mendip Rail excursion from Bristol Temple Meads to Cornwall on 3 June 2002 – this was the annual outing for Mendip Rail staff.

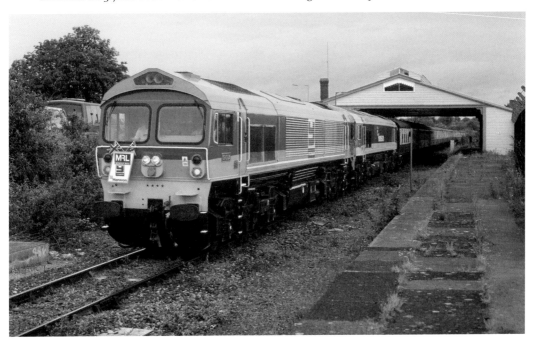

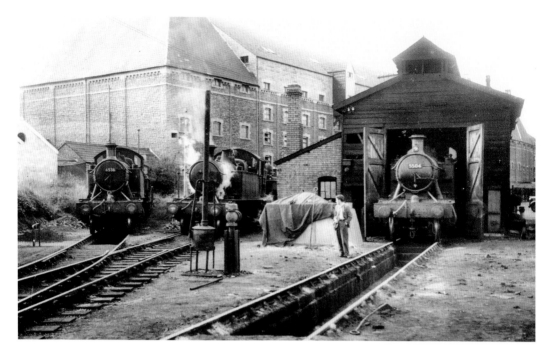

Frome: Steam & Diesel Power

Frome's wooden engine shed was situated immediately to the west of the station on the up side. It normally housed about a dozen tank locomotives, the allocation in 1947 being composed entirely of 0-6-0PTs. This *c.* 1960 view depicts three 'small prairie' tanks, including '45XX' class 2-6-2T No. 4536 and '55XX' class locomotive No. 5504. The lower picture shows class '37' diesels Nos 37057 *Viking* and 37051 *Merehead* at Clink (near Frome) on 21 June 1996 with a Euston to Cranmore special conveying guests to a class '59' locomotive naming ceremony.

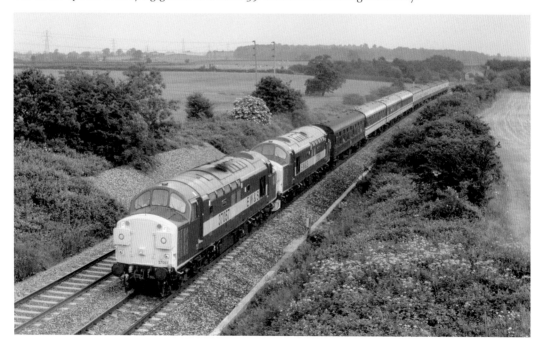

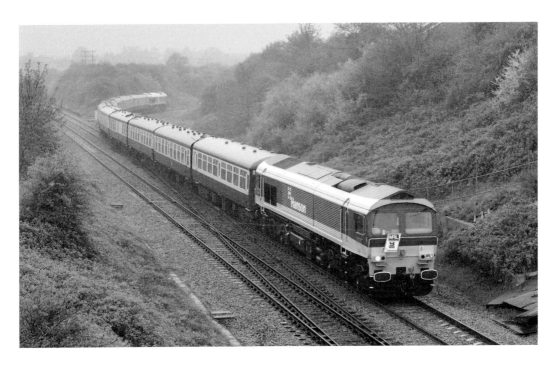

Frome: Clink Road Junction

Clink Road Junction, seen in the previous view, is the starting point for the Frome avoiding line, which runs southwards for a distance of 2 miles 17 chains before rejoining the main line at Blatchbridge Junction. The upper picture shows class '59' locomotive No. 59103 *Village of Mells* at Clink Road Junction with an excursion to Littlehampton on 3 May 2004, while the lower view shows class '50' No. 50027 *Lion* approaching the junction with the 10.35 a.m. Paddington to Paignton service on 11 May 1985.

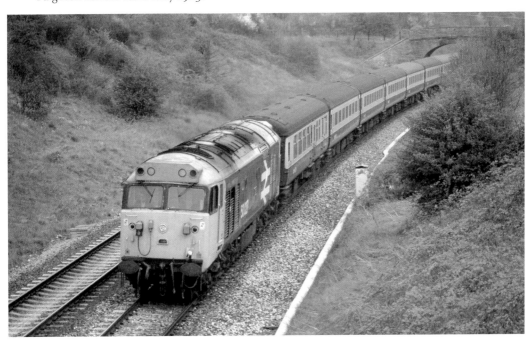

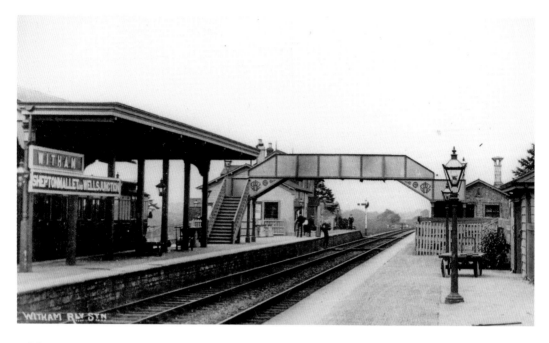

Witham: A Country Junction

Opened in 1856 as part of the Wilts, Somerset & Weymouth Railway, Witham (106 miles 60 chains) became a junction in 1858, when the first section of the East Somerset Railway was brought into use. The completion of the West of England 'cut-off' scheme in 1906 made little difference to this small station, which remained a sleepy country junction, with up and down platforms for through traffic and a bay platform on the up side. The station buildings were typical of GWR architectural practice during the 1850s.

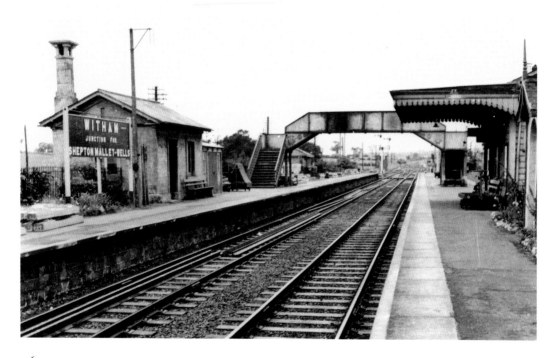

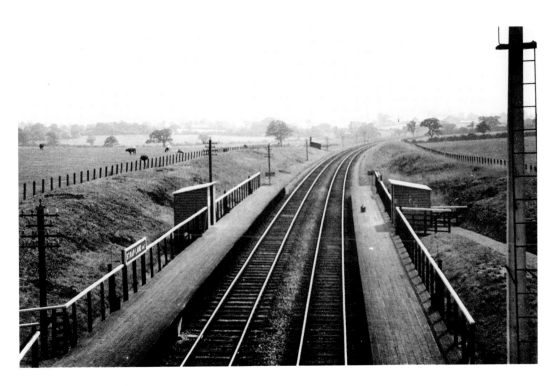

Strap Lane Halt

From Witham, the route continues south-westwards to the site of Strap Lane Halt (108 miles 36 chains), which had been opened by the GWR on 18 July 1932. The infrastructure here was primitive in the extreme, the two platforms being of sleeper construction, while the waiting shelters were simple wooden sheds. The halt was closed in June 1950, although to be fair to British Railways, it is unlikely that this remote stopping place had ever generated much traffic.

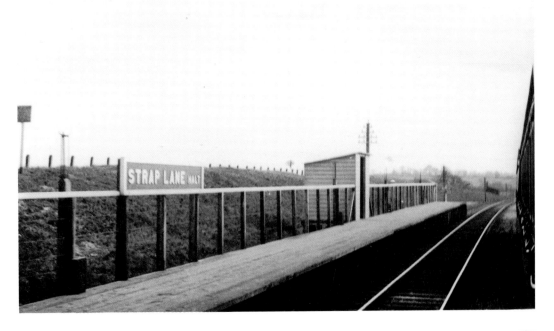

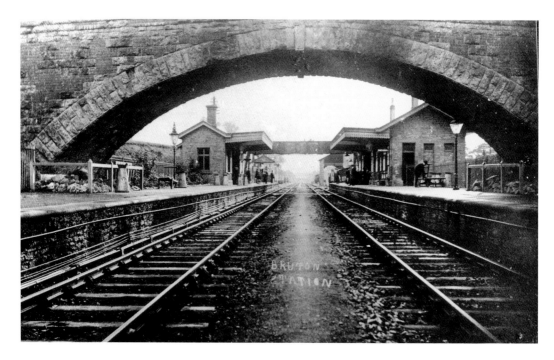

Bruton

Having surmounted a summit at Brewham, the Wilts, Somerset & Weymouth line descends towards Bruton on falling gradients as steep as 1 in 81. Bruton (111 miles 71 chains) remains in operation as part of the National Rail network, although it is now an unstaffed halt. The upper view shows the station buildings, framed by the arch of the road overbridge, around 1912, while the lower view is looking through the arch in the opposite direction during the 1920s.

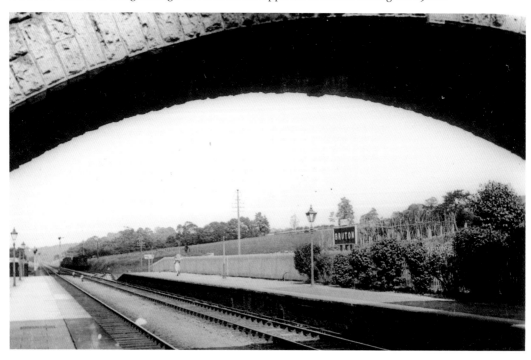

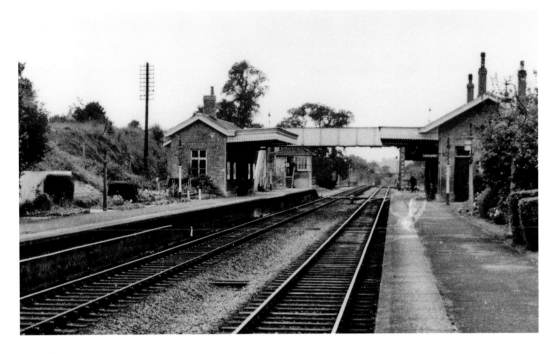

Bruton

The Brunelian-style buildings seen in these 1960s views have been replaced by modern platform shelters. In pre-Beeching days, Bruton had boasted the usual range of facilities, including a goods shed, cattle loading pens, loading docks and a 5-ton yard crane. The goods yard was closed in 1965, and the signal cabin was abolished in December 1983. Despite this pruning of facilities, Bruton has remained relatively busy, and in recent years, this Somerset station has been used by around 25,000 passengers per annum.

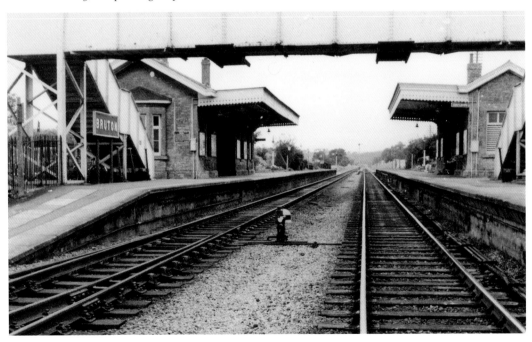

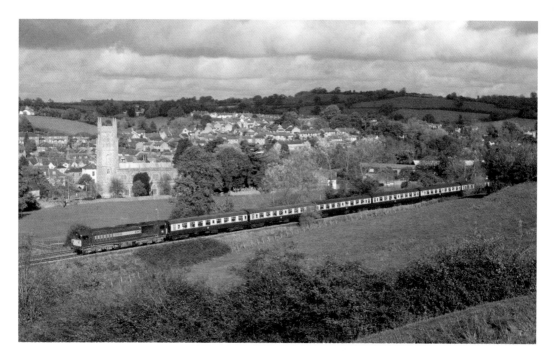

Bruton: Trains in the Landscape

Above: This panoramic view of Bruton shows class '58' heavy freight locomotive No. 58030 at the head of the Pathfinder Tours 'Tone Bone' rail tour from Crewe to Taunton on 27 October 2001. *Below*: Class '47' locomotive No. 47811 speeds past Bruton with the 9.30 a.m. Paddington to Penzance First Great Western service on 24 August 2002. The church of St Mary the Virgin, with its typical 'Somerset-style' west tower, features prominently in the background.

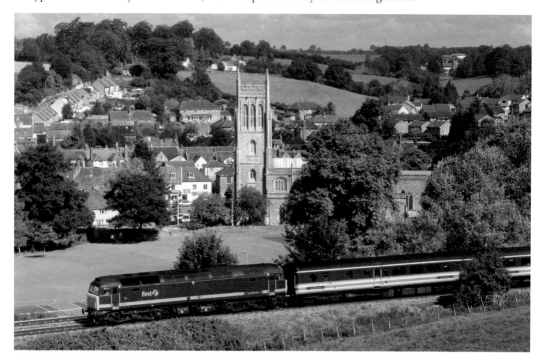

Castle Cary

About a mile beyond Bruton, down trains pass beneath the abandoned Somerset & Dorset Joint line, which once formed part of an alternative route to the South Coast. Beyond, the Wilts, Somerset & Weymouth route continues to Castle Cary (115 miles 29 chains), the junction for Weymouth. In steam days, the layout here had featured up and down platforms for passenger traffic, the main station building being on the up side; an additional platform has now been provided on the down side for Weymouth services.

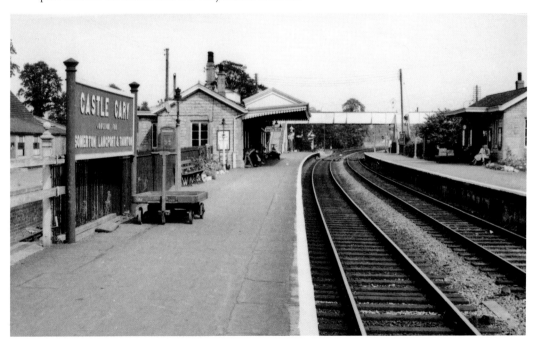

Castle Cary

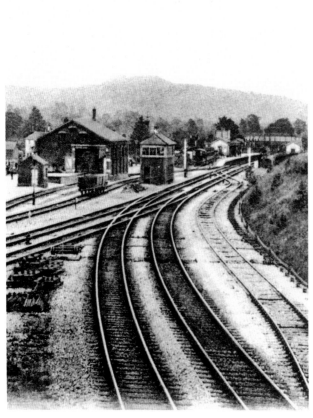

Above: Castle Cary Junction, at the west end of the station, is the point at which the 1905/06 Langport 'cut-off' parts company with the earlier Wilts, Somerset & Weymouth route. This view of around 1912 shows the diverging routes, the WS&W line to Weymouth being prominent in the foreground, while the 'cut-off' continues south-westwards. The goods yard (closed 1966) and signal box can be seen to the west of the platforms on the up side.

Below: Class '59' locomotives Nos 59001 *Yeoman Endeavour* and 59101 *Village of Whatley* pass onto the 'cut-off' line, as they accelerate away from Castle Cary with the 'Cornish Quarryman' rail tour from Bristol to Penzance on 28 May 2001 – the annual Mendip Rail staff outing. Castle Cary has prospered in recent years and, by 2010/11, it was generating around 275,000 passenger journeys per annum.

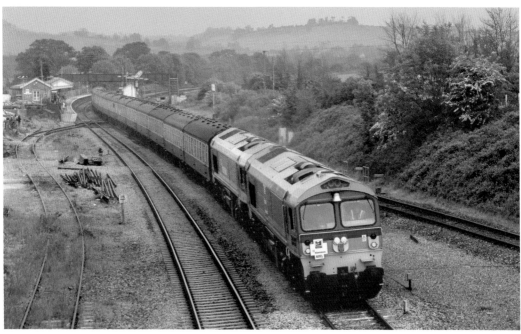

Alford Halt

Having parted company with the Wilts, Somerset & Weymouth route at Castle Cary, westbound trains race along the 1905/06 'cut-off', which provides an easy route across the dead-flat Somerset Levels. Prior to rationalisation, there had been seven intermediate stations on this westernmost section of the line, one of these being Alford Halt (117 miles 35 chains) – an unstaffed stopping place that served nearby Alford, a small village on the River Brue. It had no public goods facilities, although Alford signal box, about half a mile to the east, controlled access to a group of War Department sidings that had been installed during the Second World War. Alford was closed on Saturday 8 September 1962.

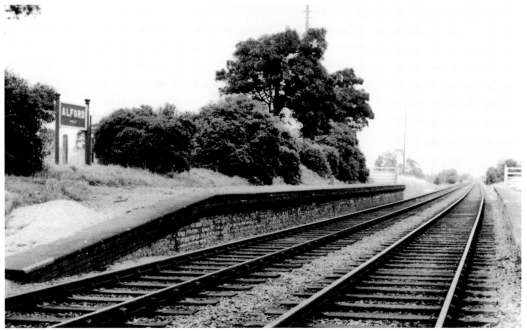

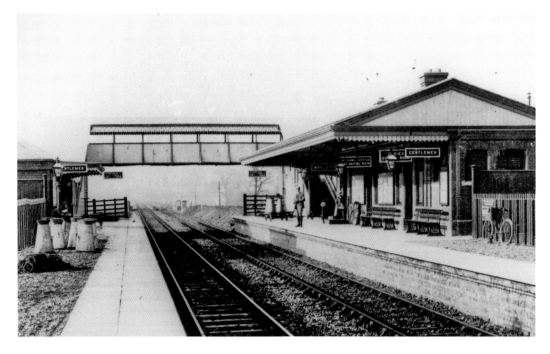

Keinton Mandeville

Keinton Mandeville (120 miles 17 chains) was a wayside station with a Great Western station building of the now-familiar type on the up side. However, it differed slightly in relation to the standard GWR buildings erected at the eastern end of the route in that its gabled roof extended forward over the platform in lieu of a separate canopy. Other infrastructure comprised a plate-girder footbridge and a goods yard that was able to deal with coal, livestock, furniture, horseboxes and general merchandise traffic.

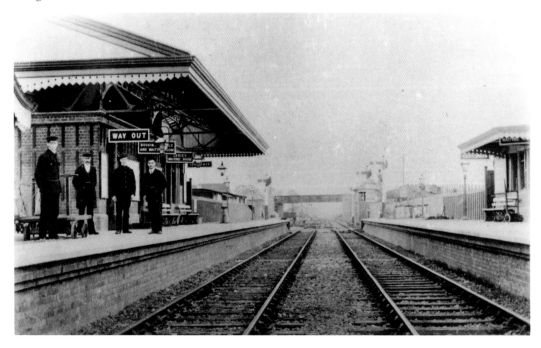

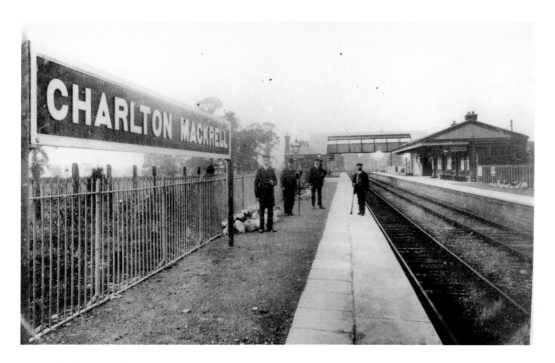

Charlton Mackrell

Charlton Mackrell (122 miles 30 chains), just 2 miles further on, was very similar to neighbouring Keinton Mandeville. The upper picture, which is looking west towards Penzance, shows the standard GWR buildings and plate-girder footbridge, while the lower view depicts a group of Great Western employees on the up platform. These photographs were probably taken shortly after the opening of the 1905/06 'cut-off'. Like other stations on this section of the line, Charlton Mackrell was closed in September 1962.

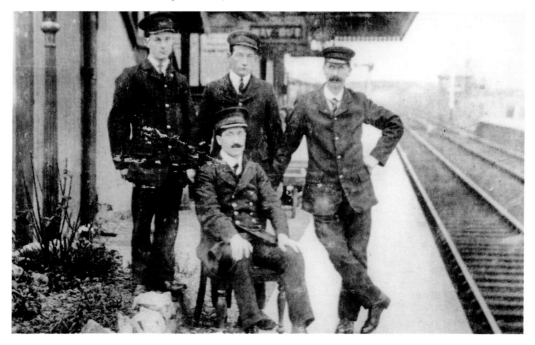

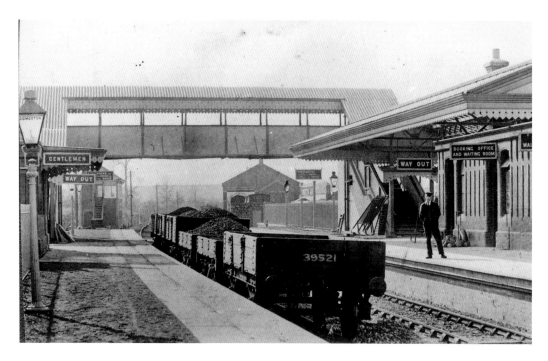

Somerton

Heading south-westwards, trains rush past the site of Somerton station (125 miles 56 chains), another victim of the 1962 closures. The engineering department wagons that can be seen in the upper picture suggest that this photograph may have been taken shortly after opening of the line. The lower picture shows Edwardian travellers beside a steam railmotor car, which is possibly car No. 15. Having passed through Somerton, trains enter Somerton Tunnel, to the west of the abandoned station, which has a length of 1,053 yards.

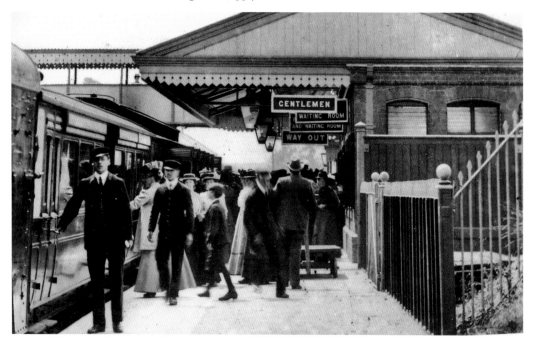

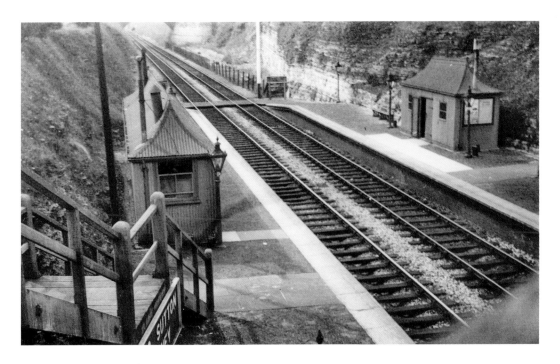

Long Sutton & Pitney

Emerging from the tunnel, trains pass the site of Long Sutton & Pitney (127 miles 70 chains). Opened on 1 October 1907, this station was situated in a deep cutting, and its station buildings were corrugated iron pagoda sheds – the main building on the down side being somewhat larger than its counterpart on the opposite platform. Although little more than a halt, Long Sutton & Pitney boasted a signal cabin and a modest goods yard, which could handle coal, livestock and general merchandise traffic.

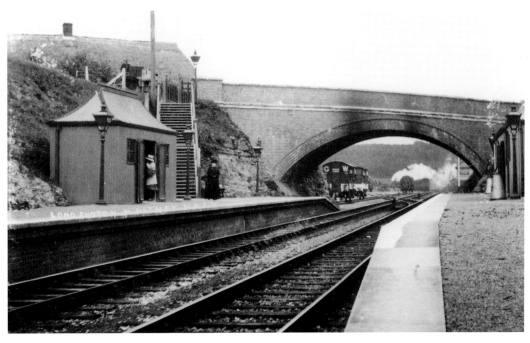

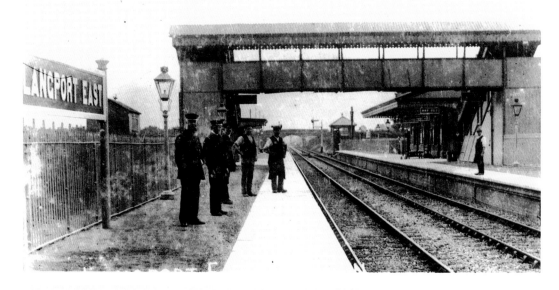

Langport East

Langport East (129 miles 73 chains), opened in 1906 and closed in 1962, marks the end of the 1905/06 'cut-off', the junction with the earlier Taunton to Yeovil branch being a mile further on at Curry Rivel Junction (130 miles 72 chains). Langport East was a passenger-only station – goods facilities being available at nearby Langport West station, on the Yeovil route. The upper picture is looking east during the Edwardian period. The main station building was on the down side, and there was a small waiting room on the up platform. A signal box can be discerned in the distance, although this cabin was subsequently abolished. The lower view, taken about sixty years later, is also looking east towards Paddington.

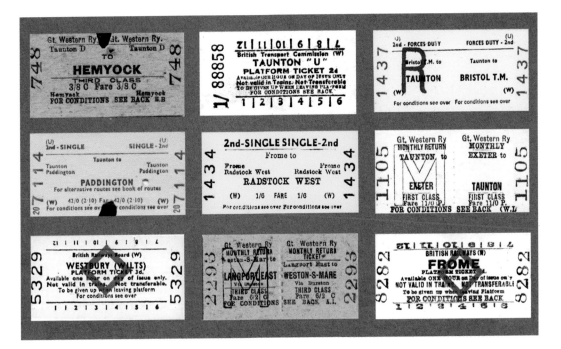

Langport East

Above: A selection of tickets from Taunton and other stations at the western end of the route, including a Great Western third class single from Taunton to Hemyock, a BR Forces Duty Return from Taunton to Bristol Temple Meads, a BR second-class single from Taunton to Paddington, dated 19 June 1970, three platform tickets, and a GWR monthly return from Langport East to Weston-super-Mare. *Below*: A glimpse of Langport West station, which was relegated to branch line status when the Taunton to Langport section was upgraded as part of the 'cut-off' scheme.

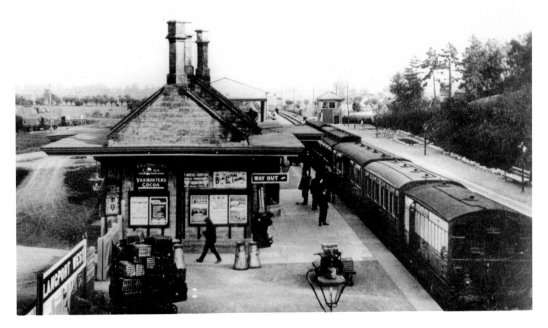

Athelney

Continuing westwards, trains reach the site of Athelney station (134 miles 74 chains), which was opened by the Bristol & Exeter Railway on 1 October 1853, and closed in 1964. There was no village here, Athelney being part of the parish of Lyng; the station was presumably called Athelney in recognition of its associations with King Alfred who, in 878, evaded the Danes by hiding in the surrounding marshes.

The station buildings and signal cabin at this Somerset station were of timber-framed construction, the main building being on the down platform, while a subsidiary waiting room was available on the up side. The upper view is looking west towards Penzance around 1962, while the lower photograph shows the hip-roofed signal box, which was initially known as Athelney West to distinguish it from a short-lived East box. Athelney signal box was closed when the area was resignalled in 1986.

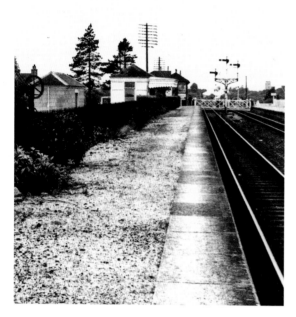

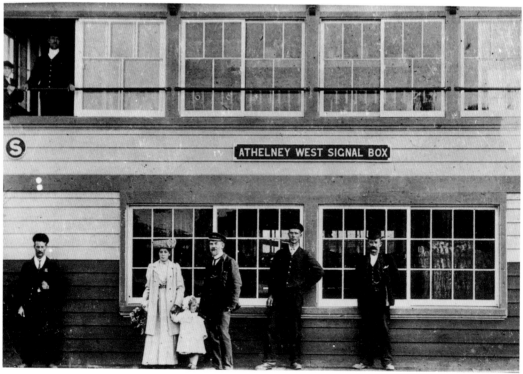

ATHELNEY WEST SIGNAL BOX

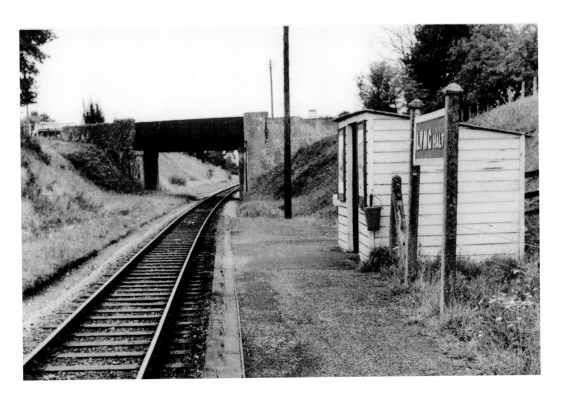

Durston & Cogload Junction

The Yeovil branch diverged eastwards from the Bristol & Exeter main line at Durston, but a new junction was brought into use at Cogload when the Langport 'cut-off' was opened in 1906. However, a 2¼-mile section of the earlier route remained in use for local traffic between Durston and Athelney Junction – the Durston Loop being the normal route for Yeovil branch trains, whereas the West of England expresses used Cogload Junction. As mentioned on page 5, the junction arrangements were further modified during the 1930s, when the GWR quadrupled the main line through Taunton and opened a flying junction at Cogload.

The upper picture shows Lyng Halt (135 miles 59 chains), opened on 24 September 1928 as the only intermediate stopping place on the Durston Loop. The lower view shows Durston station, looking towards Bristol around 1963. The station nameboard bears the words 'Durston Change for Castle Cary, Yeovil and Weymouth Lines'.

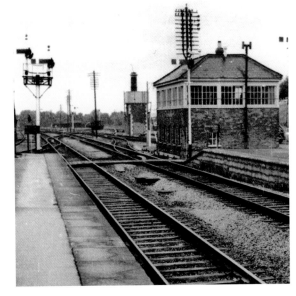

Creech St Michael

Above: Cogload Junction under construction. *Below*: There was no station at Cogload, although on 13 August 1928 a halt was opened at Creech St Michael, about a mile beyond the junction. The platforms here were sited beside the up and down relief lines, there being no requirement for platforms on the main lines. Creech St Michael was the setting for an accident that occurred on 13 March 1945, when a down express headed by 'Castle' class 4-6-0 No. 5050 *Earl of St Germans* ran into the back of a freight train.

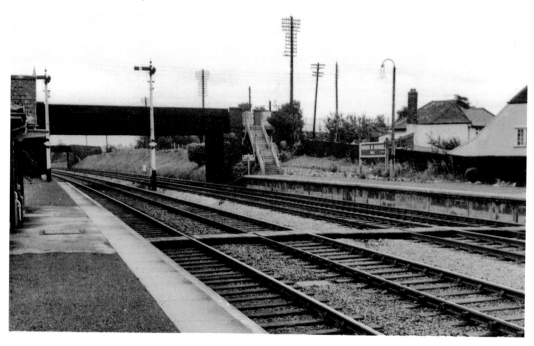

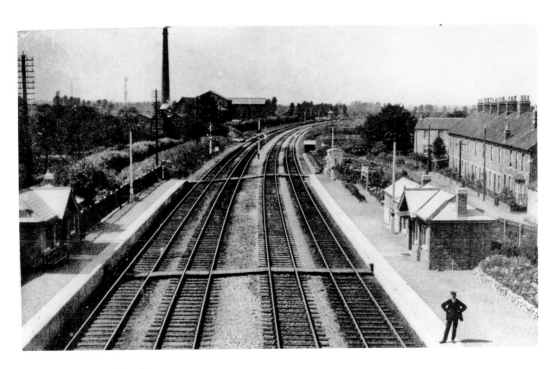

Creech St Michael

Above: A general view of Creech St Michael, photographed from the road overbridge around 1930. The platforms were 300 feet long, while public access was by means of steps from the adjacent road overbridge. This station was closed in 1964. *Below*: Class '47' No. 47847 passes Creech St Michael with the 9.13 a.m. Liverpool to Plymouth Virgin CrossCountry service on 24 August 2002. The train is composed of a West Coast Mk3 set, with unpowered DVT No. 82138 directly behind the locomotive.

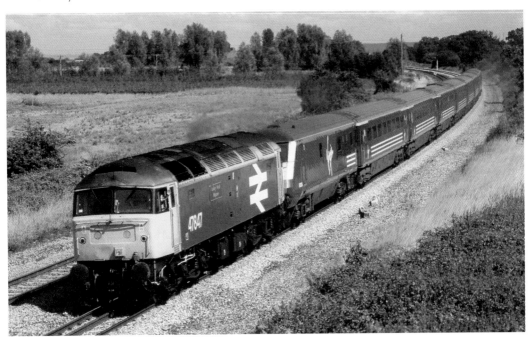

Taunton

From Creech St Michael, down workings proceed westwards alongside the River Tone. In steam days, the approach to Taunton passenger station was over a complex web of trackwork, the quadruple-tracked main line being flanked by a goods avoiding line and extensive sidings on both sides. The now closed Chard branch diverged southwards at Creech Junction, and the main line then continued westwards to Taunton East Junction, where the goods avoiding lines diverged to the left. Taunton passenger station (142 miles 72 chains) was only a short distance further on.

When opened in 1842, Taunton had been a single-sided station with separate platforms for up and down traffic on the same side of the running lines. As traffic continued to increase, the original facilities were progressively improved, and by the end of the nineteenth century, the station consisted of up and down platforms and a number of terminal bays. These Victorian facilities were largely swept away as part of the government-financed improvement scheme during the 1930s, when Taunton station was remodelled with four lengthy through platforms. The old down platform was retained as Platform 1 of the new station while, to the north, platforms 5 and 6 were the two sides of a double-side island platform. A further through platform on the north side of the station was designated Platform 7, while a number of additional bays, numbered 2, 3, 4, 8, 9 and 10, were available for branch line and local services.

Extensive awnings covered all of the platforms, all of these being adorned with traditional Great Western 'V-and-hole' valancing. The upper picture is looking eastwards along the island platform around 1933, and the lower photograph is looking westwards from Platform 7.

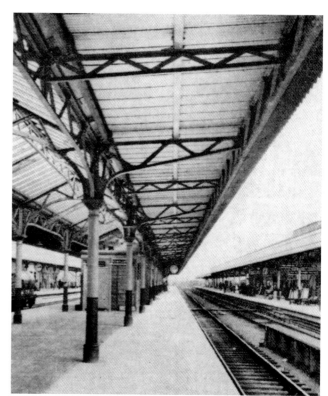

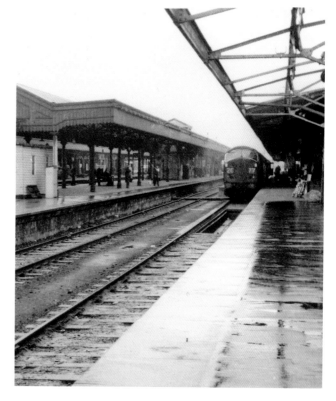

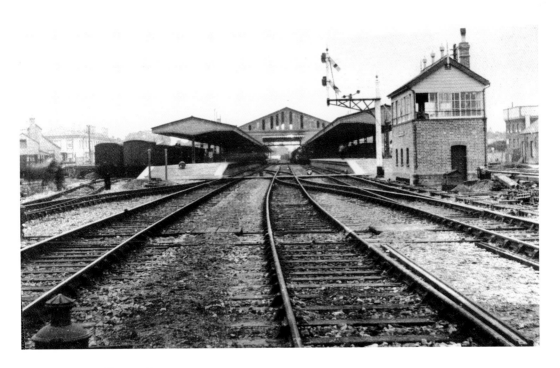

Taunton: Vintage Scenes

Above: A view of the station prior to reconstruction, showing the Brunelian train shed that once covered the main up and down platforms. *Below*: An unidentified small-wheeled saddle tank stands in Platform 3 (now Platform 6), with a local passenger train around 1930. The engine is possibly '850' class 0-6-0ST No. 1925, which was allocated to Taunton during the early 1930s, and was recorded as 'the down-side shunter' on 13 August 1933.

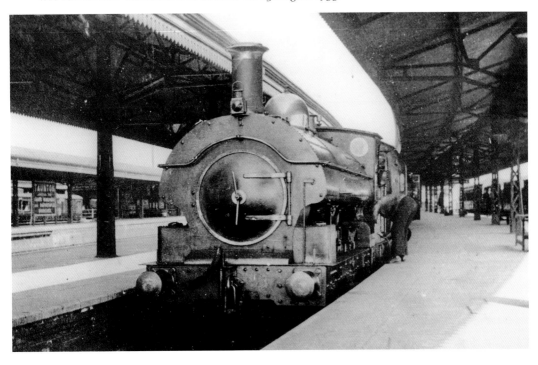

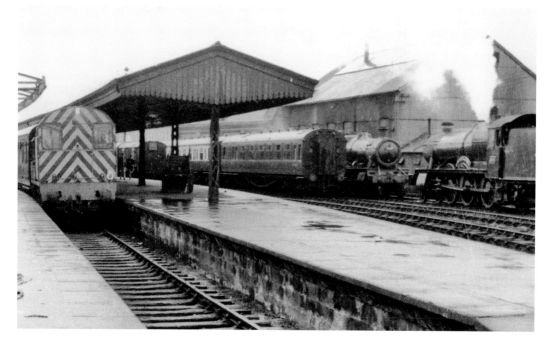

Taunton

These two pictures show platforms 3 and 4, the Minehead and Barnstaple branch bays at the west end of Platform 1, together with part of Taunton's busy motive power depot, which can be seen in the background. Although the Minehead line was closed in 1971, this popular seaside branch was later reopened as a steam-worked 'heritage line'. The present-day Taunton station has six platforms, Nos 2, 3, 4 and 5 being the main through platforms, while Nos 1 and 6 are the two remaining bays.

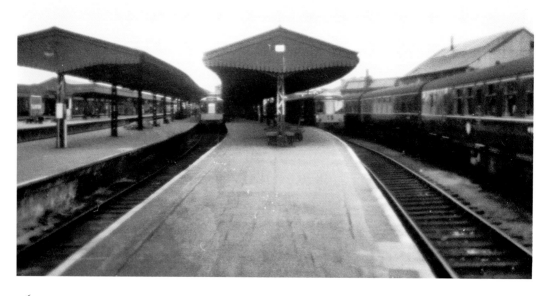